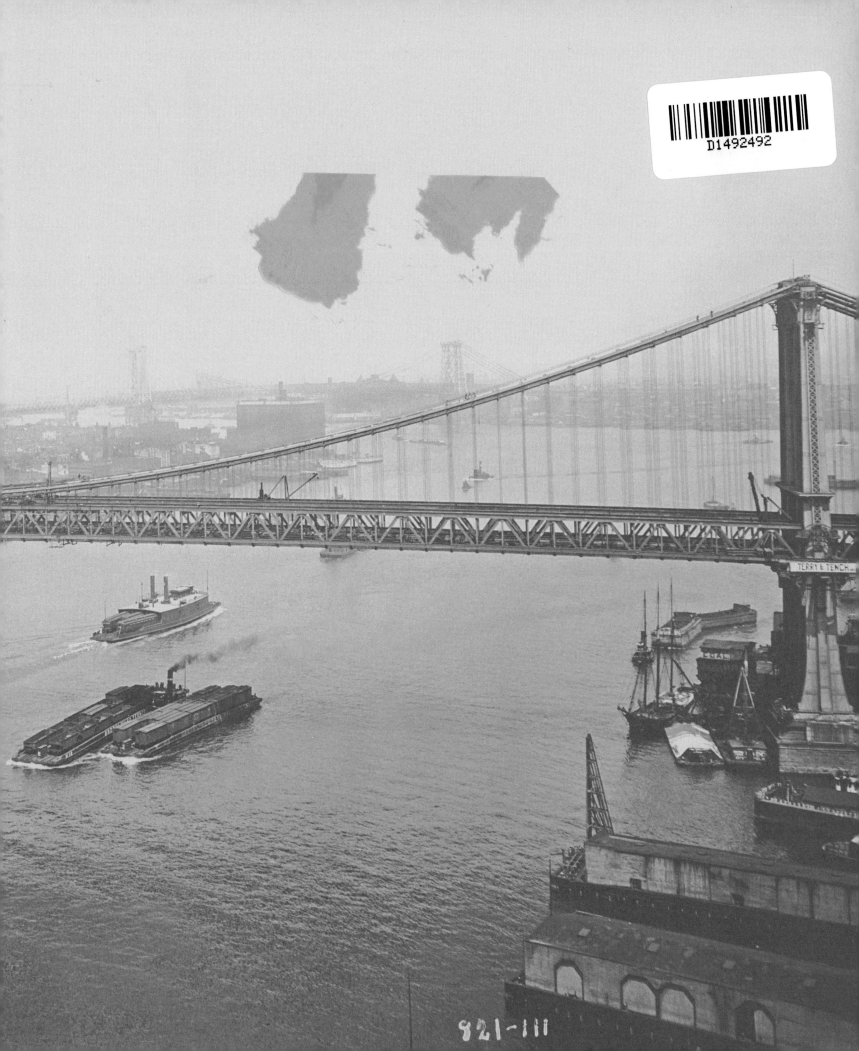

821-111

NEW YORK RISES

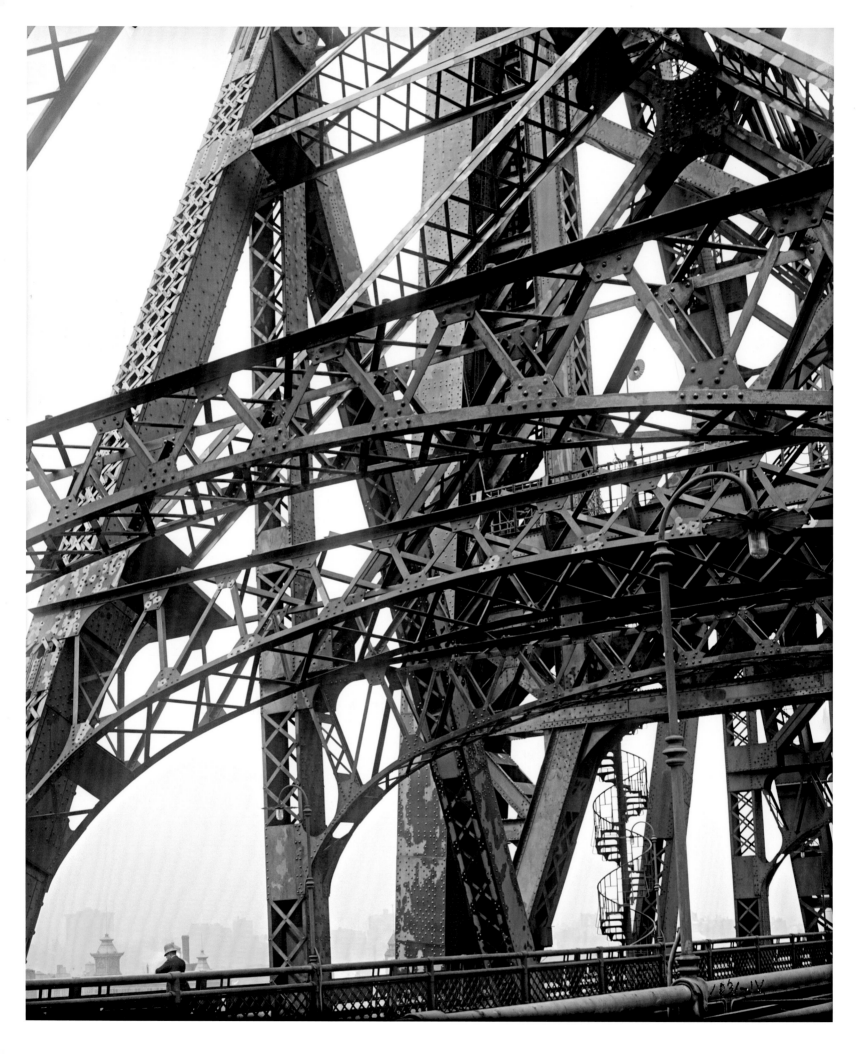

NEW YORK RISES

PHOTOGRAPHS BY
Eugene de Salignac

FROM THE COLLECTIONS OF THE NEW YORK CITY
DEPARTMENT OF RECORDS/MUNICIPAL ARCHIVES

ESSAYS BY
Michael Lorenzini AND **Kevin Moore**

aperture

This project was made possible, in part, with generous support from The Durst Organization and the Lynford Family Charitable Trust.

FRONT COVER: Brooklyn Bridge, showing painters on suspenders, October 7, 1914
BACK COVER: Williamsburg Bridge, cutting steel plate, September 10, 1915
FRONT ENDPAPERS: Manhattan Bridge, from top of Brooklyn Bridge tower looking north, June 29, 1909
BACK ENDPAPERS: Manhattan Bridge, looking north on Manhattan approach, May 29, 1911
FRONTISPIECE: Queensboro Bridge, from Tower 3 looking west, August 16, 1910

A NOTE ABOUT THE PHOTOGRAPHS

The captions are based on the entries in Eugene de Salignac's logbooks. For consistency, slight changes have been made to spelling, punctuation, and abbreviations. Additional information is in brackets.

De Salignac worked with an eight-by-ten-inch field camera using glass-plate negatives; whenever possible the reproductions have been made from high-resolution scans of his negatives, using his vintage prints as match prints for tonal range, exposure, and cropping. A certain level of imperfection is to be expected from a glass-plate negative, and the guideline in retouching was not to create a perfect negative but to reduce the dust, scratches, and other effects of nearly one hundred years of handling, which were not part of the artist's original intention.

EDITOR: Nancy Grubb
DESIGNERS: Miko McGinty and Rita Jules
PRODUCTION: Sarah Henry

The staff for this book at Aperture Foundation includes:
Ellen S. Harris, *Executive Director*; Michael Culoso, *Director of Finance and Administration*; Lesley A. Martin, *Executive Editor, Books*; Susan Ciccotti, *Production Editor*; Matthew Pimm, *Production Director*; Andrea Smith, *Director of Communications*; Kristian Orozco, *Director of Sales and Foreign Rights*; Diana Edkins, *Director of Exhibitions and Limited-Edition Photographs*; Sofia Gutierrez, Catherine Archias, and Elliot Black, *Work Scholars*

First edition
Printed and bound in Italy
10 9 8 7 6 5 4 3 2 1

LIBRARY OF CONGRESS CATALOGING-IN-PUBLICATION DATA

Salignac, Eugene de, 1861–1943.
 New York rises / photographs by Eugene de Salignac ; essays by Michael Lorenzini and Kevin Moore. — 1st ed.
 p. cm.
 ISBN-13: 978-1-59711-013-6 (hardcover : alk. paper)
 ISBN-10: 1-59711-013-2 (hardcover : alk. paper)
 1. Architectural photography—New York (State—New York. 2. New York (New York)—Buildings, structures, etc.—Pictorial works. 3. New York (New York)—History—Sources. 4. Photographers—United States—Biography. I. Lorenzini, Michael. II. Moore, Kevin D., 1964- III. Title.

TR659.S24 2007
779'.47471—dc22

 2006030589

Aperture Foundation books are available in North America through:
D.A.P./Distributed Art Publishers
155 Sixth Avenue, 2nd Floor
New York, N.Y. 10013
Phone: (212) 627-1999
Fax: (212) 627-9484

Aperture Foundation books are distributed outside North America by:
Thames & Hudson
181A High Holborn
London WC1V 7QX
United Kingdom
Phone: + 44 20 7845 5000
Fax: + 44 20 7845 5055
Email: sales@thameshudson.co.uk

aperturefoundation
547 West 27th Street
New York, N.Y. 10001
www.aperture.org

The purpose of Aperture Foundation, a non-profit organization, is to advance photography in all its forms and to foster the exchange of ideas among audiences worldwide.

Copublished with the New York City Department of Records/Municipal Archives

Michael R. Bloomberg, Mayor
Brian G. Andersson, Commissioner

CONTENTS

Eugene de Salignac: 7
Out of the Shadows

MICHAEL LORENZINI

A Ragged Order 21

KEVIN MOORE

Plates

BROOKLYN BRIDGE 34

WILLIAMSBURG BRIDGE 44

MANHATTAN BRIDGE 60

QUEENSBORO BRIDGE 74

THE MUNICIPAL BUILDING 86

INSPECTING THE CITY 90

ACCIDENTS 106

THE DEPRESSION 116

WORKERS 124

NEW YORK CITY MUNICIPAL ARCHIVES 142

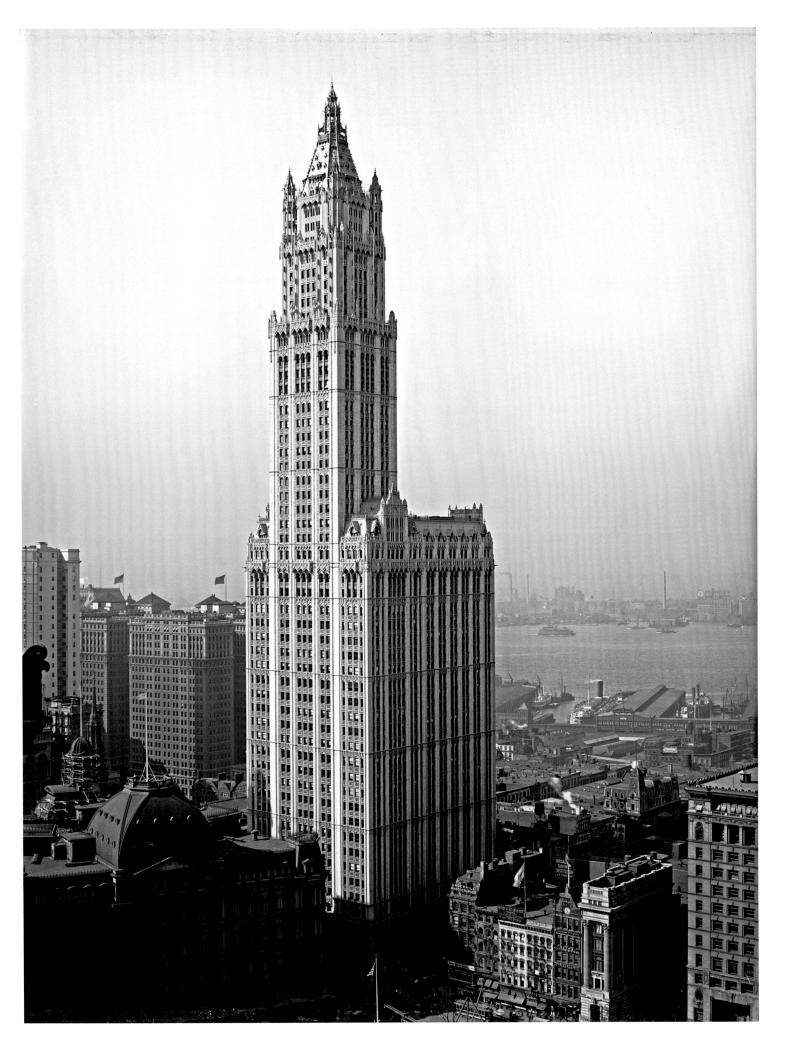

EUGENE DE SALIGNAC
OUT OF THE SHADOWS

MICHAEL LORENZINI

At first, he didn't have a name. In fact, he wasn't even a he yet. "He" was simply a collection. "He" was twenty thousand eight-by-ten-inch glass negatives sitting in the basement of New York City's Municipal Archives. In the fall of 1999 the Archives was engaged in research for a potential book — not this book, but a book on workers that was to include photographs from all of the Archives' collections. At the end of our research I tackled one of our largest collections, the Department of Bridges/Plant and Structures. Arranged in chronological order, the photographs (copied onto spools of microfilm) match up with five handwritten logbooks. I'm not sure what first tipped me off. After covering ten years or more of the collection, I said to myself, "Wow, this guy was a good photographer." That stopped me. Why had I said "this guy"? We had assumed that these photos were the work of a team of photographers, probably many over the years. And yet subconsciously I had recognized a style, a unique eye behind the camera. I picked up one of the logs and looked at the handwriting, all the same. Excited, I grabbed the next book, still the same, and the next, and the next. Then at the end of the last book, I saw a new handwriting style. And in the beginning of the first book, I found a different one. But from 1906 to 1934 it was the same writing, the same eye. It took more research to confirm, but the employment records bore out my discovery. Only one photographer worked for the Department of Bridges (later renamed Plant and Structures) for nearly thirty years, and his name was Eugene de Salignac.

This was only the start; the real detective work was still to come. We did what archivists do — sift through public records. Employment records gave us a name, an address, and the year of retirement. This led to death records and the date of birth. The date of death gave us the Social Security index, which gave us the last known city of his ex-wife. That gave us the date of death of his son, which led to an obituary in the *New Orleans Times-Picayune*, which gave us the name of his granddaughter. From there, it was a simple matter of typing her name into an Internet search engine, which yielded exactly one match, and a simple phone call confirmed it. Six months later I was giving a tour of the Archives to Eugene de Salignac's granddaughter, great-granddaughter, and great-great-grandchildren.

Woolworth Building from 27th floor of Municipal Building, short focus, October 22, 1914

This much we now know: Eugene de Salignac died on November 1, 1943, in New Jersey. He was eighty-two years old. He had been retired for nine years. From October 5, 1906, to May 31, 1934, he was the sole photographer for the New York City Department of Bridges/Plant and Structures. During that time, he shot nearly twenty thousand eight-by-ten-inch glass-plate negatives. We also know that he was a brilliant photographer, both technically and aesthetically. We know this because almost all of his negatives and over ten thousand vintage prints have survived. These and the daily log of negatives he kept are all we have to connect with him. Yet they can tell us so much about him, about his sense of humor, his attention to craftsmanship, his dedication.

We know little else. We know that he married Eliza Jane Cross in 1887 and that they had two children — a girl, Eugenie, and a son, Leon. The 1900 Federal Census of New Jersey gives his birthplace as Massachusetts; his father was born in France, his mother, in New York. It also tells us he was a resident of Keyport. His occupation is listed as boardinghouse keeper. By 1903 he had separated from his wife. She and the children remained in New Jersey, and he moved to New York, where he started working for the Department of Bridges. The annual budget reports of the City of New York tell us that in 1911 his salary was $1,200 a year, and by 1931 he was making $2,580 a year. They also give the home addresses of all employees. De Salignac spent those years moving between four residences on West Twentieth Street and West Twenty-first Street. Probably all were lodging houses, single-room-occupancy hotels. In 1925 he was interviewed for the New York census. It lists him as a "Lodger, white male, age 64, born US, citizen, engineer."

So is this the simple story of a lonely and dedicated public servant? Here is another story: Eugene de Salignac was descended from French nobility and could have taken the title of count, as did his father. The twelfth-century de Salignac family castle still stands in the Dordogne, in the south of France. A seventeenth-century ancestor was François de Salignac de La Mothe Fénelon, a famous theologian and archbishop of Cambrai. Eugene's maternal great-grandfather, John Ordronaux, was a privateer in the War of 1812, who seized more than three million dollars' worth of goods from British ships. Eugene's granduncle, also named John Ordronaux, was an eminent

law professor at Columbia who helped develop the theory of the insanity defense. The valedictorian of Columbia Law School still receives the John Ordronaux Prize. Eugene's mother, Clara Servatius, was the daughter of Baron Bartholemew Servatius.

When Eugene de Salignac was born in Boston in 1861, his father, Colonel Eugene de Salignac, was running a private school to train Union officers for the Civil War. In 1915 General Nelson Miles endorsed an early plan for a type of ROTC, with these words: "In 1859 and 1860, when war was threatened, there was formed in the city of Boston an independent corps of cadets, composed largely of young men in Boston and Harvard students; and, under the control of an experienced French officer, Colonel Salignac, became one of the best-drilled and instructed organizations that I have ever known." The family was apparently also prominent in Boston intellectual circles. Yet de Salignac ended up marrying a girl who shows up in the 1880 census working as a clerk in a candy store. They have two kids, he seems to drift between jobs, and then at forty years of age, he starts working for the city.

With the help of his great-granddaughter, Michelle Preston, we have learned much about his family, and thanks to his photo logbooks, we know his daily schedule for nearly thirty years, but Eugene de Salignac himself remains an enigma. In fact, the only known photograph of him is as a small child. What education did he have? Where did he learn photography? Was he formally trained, a skilled amateur, or did he learn on the job? Did he follow trends in photography or make an effort to see work by Alfred Stieglitz and other fine-art photographers in the city? Did he take personal photographs outside of work and, if so, what became of them?

We know that in 1903 he started working for the Department of Bridges, and it is then that his handwriting appears in the logbooks, but only in the final version. Another "Field Log" exists from those early years, and in this book his handwriting does not appear until October 5, 1906. The listed photographer for the Department of Bridges from 1901 to 1906 was a Joseph Palmer. According to his death certificate, Palmer fell ill on October 5, 1906, and died ten days later. It seems likely that de Salignac had been working as an assistant, then moved into the job upon his predecessor's demise. By 1909 he is listed in the civil service records as the official photographer. If some of those pre-1906 photos were taken by de Salignac, we will never know, but

apprenticeship to Palmer likely made up at least part of his training. Palmer had worked for the city for forty years (probably not solely as a photographer), and he too was skilled in his craft, although with a more traditional nineteenth-century style.

De Salignac's granddaughter, Dolores Parham, was only thirteen when he died, and she never knew him to be a photographer. She believed that he was a retired stockbroker, since he left the family an inheritance of oil stocks, which were probably the remains of his 1914 inheritance from his sister, Countess Marie de Salignac. Parham remembered her grandfather as a jovial, vibrant man and a habitual smoker of cigars. Her grandmother (his ex-wife) would forbid him to smoke indoors when he visited his son Leon's house in New Orleans. Leon would become a civil engineer — probably an inevitable fate, given his early exposure to some of the greatest engineering feats of the age. In a 1908 photograph of the Queensboro Bridge roadway under construction (opposite), there sits on the guardrail of the bridge, looking into the camera, a well-dressed young boy of about twelve — the same age Leon de Salignac would have been that year, and confirmed to be him by his daughter. Yet Leon never spoke to his family about what his father had done or about those early years in New York.

We learn other things about de Salignac and his job from the photographs. We know that by the 1920s he had use of a city car. It appears in many photographs, with the city seal on the side and a reinforced platform on top, where he stood to get the required elevation for many of his photographs. We know something of his schedule and daily rhythm, both from the dates of the photographs and from the fact that he photographed many accidents on the city's bridges, photographs that were obviously taken very soon after they occurred. Sometimes the caption for an accident photograph has the marginal notation "Sunday," probably to remind him to file for overtime.

De Salignac started photographing New York City at a time of unprecedented change. The city was prosperous and expanding. Bridges were going up, the towering Municipal Building was rising in lower Manhattan, but on the street, horses and trolleys still ruled. The automobile was just starting to appear, and many parts of the city were still rural, with dirt roads even in parts of upper Manhattan. In the early part of the twentieth century, most construction was still being done by hand, with teams

Queensboro Bridge, looking through deck,
longer focus, July 16, 1908
[with de Salignac's son, Leon]

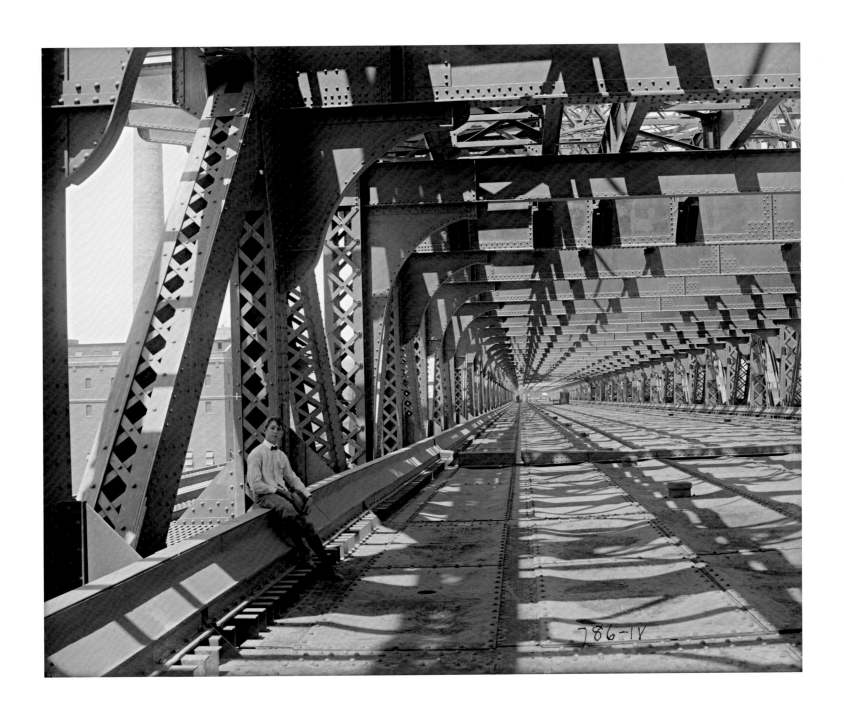

of horses bringing in materials and bulky steam shovels (actually powered by steam) digging the foundations.

As photographer for the municipal agency responsible for building this new infrastructure, de Salignac was called upon to document progress and process. A fair number of his shots hold little interest for the lay viewer, concentrated as they are on the minutiae of construction techniques. However, de Salignac often pulls back to show a scene rather than just an illustration. His gem of a photo, identified in his purely functional language as "142-146-148 Delancey Street, north side, July 29, 1908," ostensibly documents workers excavating a new subway entrance (opposite). The real subject, however, is a ragged, shoeless boy who leans against a shop window, beneath an enormous sign in Yiddish and English. The ditchdiggers are shoved to the lower-left corner of the frame.

Bridges were essential to the expansion of a rapidly growing multi-island metropolis. Ask most New Yorkers how many bridges there are in the city, and you might get an answer ranging from "five" to "ten." There are actually more than two thousand bridges serving New York City: 76 over water, 329 railroad, 1,011 over land, and the rest serving parks, subways, or as private pedestrian bridges. After the consolidation of New York City in 1898, all waterway bridges fell under the jurisdiction of the Department of Bridges. During the next decade they built nineteen new bridges throughout the five boroughs and were responsible for maintaining forty-five major existing bridges.

De Salignac's assignments were eclectic. His three major projects document the construction of the Manhattan Bridge, the Queensboro Bridge, and the Municipal Building. All negatives had a unique sequential number scratched into the emulsion. These numbers were then faithfully recorded in the logbooks, and notations were made regarding copy negatives or other shots not taken by him. His negatives of the Manhattan Bridge series were designated with the roman numeral *iii* (it was the third East River bridge), and those of the Queensboro were assigned numbers beginning with *iv*. The Municipal Building was included in the general numbering sequence, along with his photos of all other bridges, of the BMT subway construction, ferryboats, trackless trolleys, buses, street scenes, accidents, construction workers, office

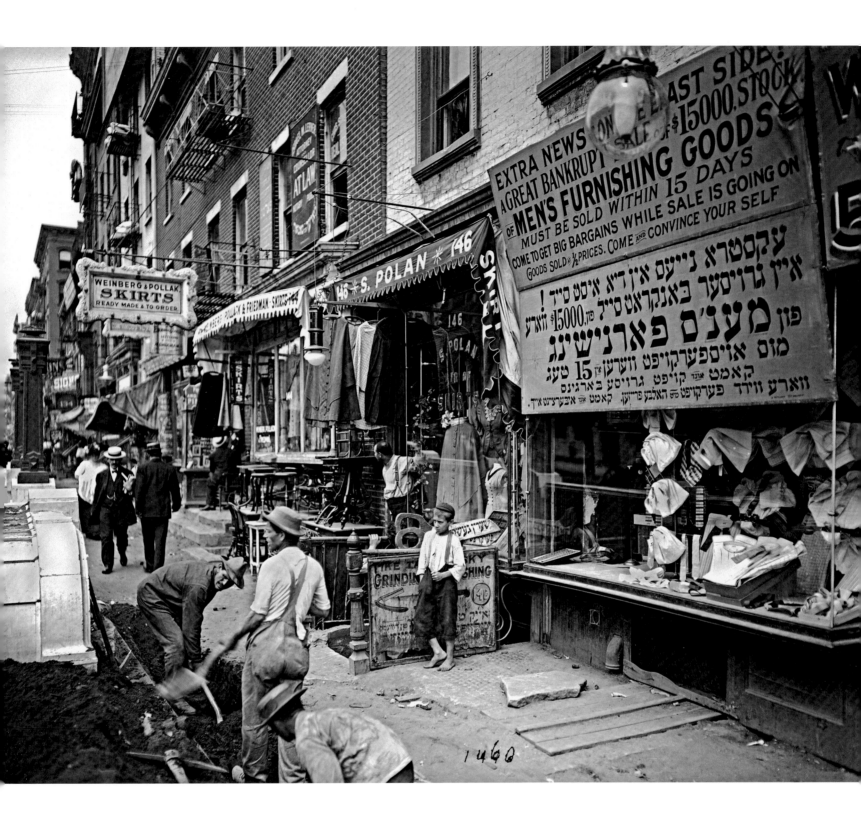

142-146-148 Delancey Street, north side,
July 29, 1908

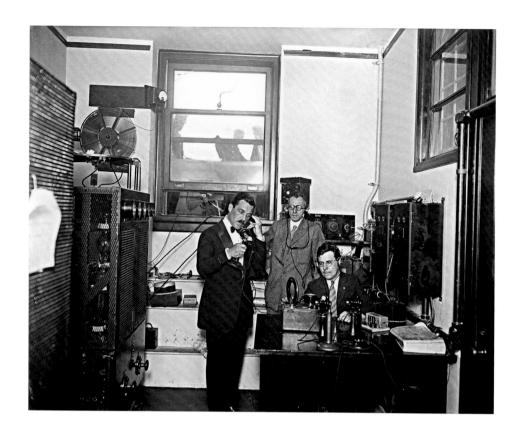

Radio Room 2510, Municipal Building, Commissioner Grover A. Whalen [first broadcast by WNYC], July 8, 1924

workers, panoramas, the waterfront, and so on. Certain waterfront series are labeled "for Department of Docks and Ferries," and these images, which are missing from the general series of negatives, can be found in the Department of Docks and Ferries collection of glass plates at the Municipal Archives. De Salignac's services were also loaned out to the Sanitation Department and to the Department of Weights and Measures, and he was called upon by Mayor Jimmy Walker to record numerous occasions, including the signing of his oath of office. He even shot driver's-license photographs for livery drivers.

In addition, he photographed the very first broadcast of WNYC Radio, in 1924 (above). Grover A. Whalen was an early advocate of radio, and as commissioner of the Department of Plant and Structures, he pushed through the proposal for a city-operated radio station in 1922. It would take another two years to locate a transmitter (one was bought secondhand from Brazil) and to build the station. The station's offices were located in the Municipal Building, four floors up from de Salignac's studio. He was often called upon to photograph various personalities who showed up, as well as the many musical broadcasts that took place there — sometimes on the building's rooftop.

By the time de Salignac retired, the city had fallen into the depths of the Depression. This too he photographed, documenting the breadlines and shelters created by a city struggling to provide resources for its increasingly needy inhabitants. These photographs were clearly taken to promote the city programs, but they also

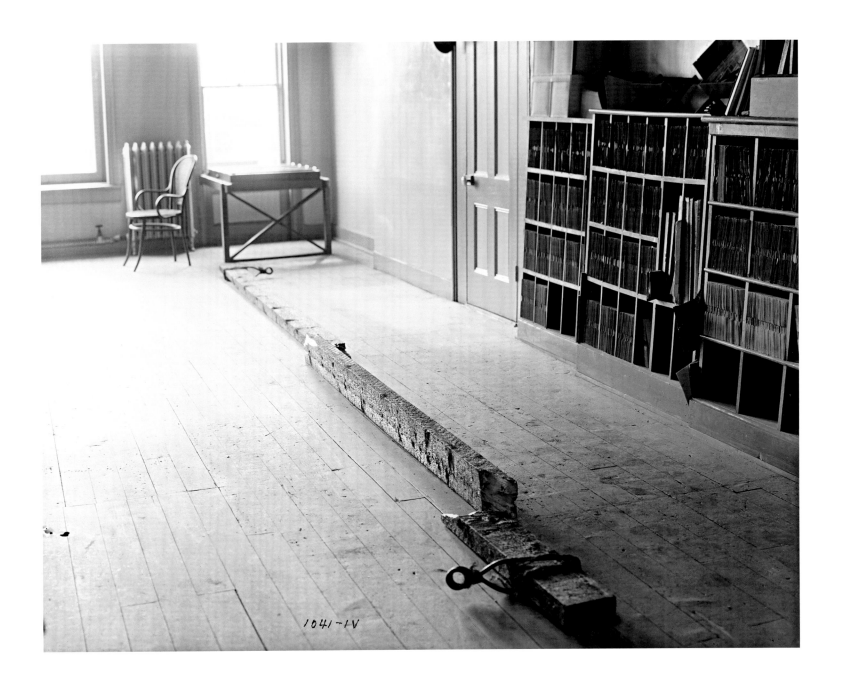

1041-1V

Showing beam from scaffold center-up and two ends down, taken at office, December 30, 1910 [This photo was taken in de Salignac's studio on Washington Street, in Brooklyn. On the shelves are rows of his glass plates, and on top a plate can be seen drying in a rack. The table by the window seems to be set up with an apparatus for making Velox and cyanotype contact prints.]

Brooklyn Bridge, general view from
Brooklyn tower, April 24, 1933

capture the humanity and suffering of his subjects. There are few construction photos from the final years of his service; most images from those years reflect a city just holding on, the cracks showing.

Every week for thirty years de Salignac ventured out into an expanding city, ultimately capturing twenty thousand pieces of it, each on its own sheet of glass. Looking at them today, we see daily lives long gone and the construction of monumental projects that will long remain. But we also see Eugene de Salignac: an eye for beauty, an eye for tragedy, a sense of humor and a sense of awe. Perhaps most notable was his spirit of adventure, his willingness to go to great lengths and great heights to capture the excitement of a city that was changing in wondrous new ways. For instance, in 1933 de Salignac took a series of panoramas from the top of one of the Brooklyn Bridge towers (opposite). He then went to the top of the Manhattan Bridge, where he had stood twenty-seven years earlier, and did the same. He was seventy-two years old. One year from reluctant retirement, he climbed to the top of the tower holding an eight-by-ten-inch glass-plate camera and at least six sheets of glass. He probably had an assistant to help him with the equipment, which must have weighed about fifty pounds, but he still had to climb the towers himself. There is only one way to get to the top of those towers: to walk up the two-foot-wide cable from the roadway to the tower, 380 feet above the river.

In April 1934 de Salignac petitioned the Board of Estimate to continue in service until December 31, 1935. The Commissioner of Plant and Structures "certified that applicant has been employed for 30 years; that he has not been absent outside of his vacation period during the last year; that he is in very good physical and mental condition . . . that the services of applicant are so unique and extraordinary and of such a highly specialized nature to be necessary and advantageous at this time to the public service." However, the board resolved to "hereby retire him from city-service, to take effect May 31, 1934." His granddaughter says that even after retirement he remained active, going ice-skating every winter until his death. And yet, she says, she never saw him with a camera. He would visit the family in New Orleans every year, going for long walks around the city, but he never took a camera with him. Perhaps he was tired of taking photographs. Perhaps it had been only a job to him and not a

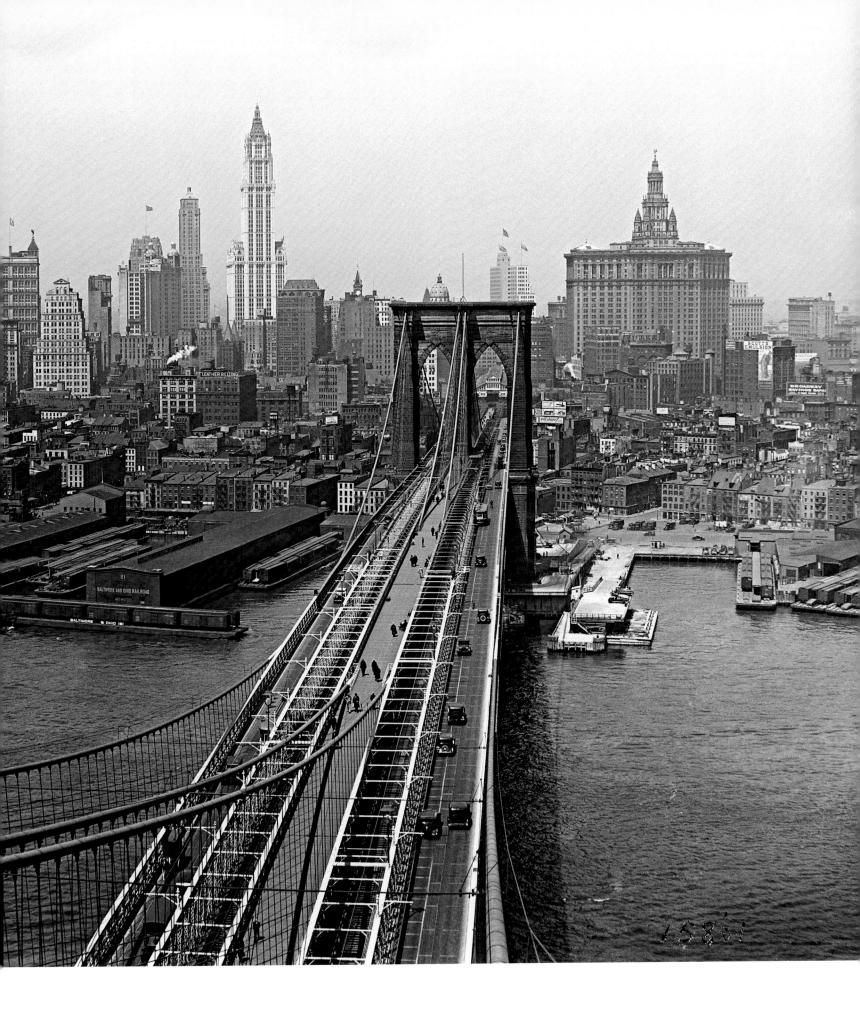

passion. Or perhaps the photographs he would get from a portable modern camera didn't satisfy him.

After his retirement, another photographer continued in his place until 1938, when the Department of Plant and Structures was absorbed into the new Department of Public Works. De Salignac's glass negatives never left the Municipal Building, where his darkroom had been, and eventually they were taken in by the Municipal Library. The presentation binders of photographs that he made throughout his career were scattered among many agencies, and some have turned up as far away as Texas. These binders contain thematically arranged photos, identified with his handwritten captions in gold or black ink. In 1987 the Museum of the City of New York turned over a collection of 114 of his photo albums to the Municipal Archives. This act finally reunited de Salignac's vintage prints (still anonymous at that point) with the glass plates the Archives had acquired after their formation in 1950. In 1999 the Archives received "four cubic feet" of soot-covered photographs from a Department of Transportation carpentry shop under the Williamsburg Bridge. These turned out to be several hundred vintage gelatin-silver prints and cyanotypes by de Salignac. The cyanotypes had probably been made as cheap reference photos for engineers, but many are strikingly beautiful in their intense tones of blue.

In the 1930s the Works Progress Administration Federal Writers' Project raided de Salignac's negatives for their book *New York Panorama*; the negatives they borrowed were never returned and may be lost forever. His striking ferryboat photo (see page 105) exists only as a print in the WPA files, identified by his negative number but not by his name. And as recently as 2005, a few thousand more de Salignac prints in their original albums turned up in another DOT storeroom, in the old Battery Maritime Building — the setting of his Staten Island ferry photo. His photographs have been used in many ways throughout the years, in newspapers, documentary films, posters, postcards,

and history books. But never with attribution: credit has never before been given to de Salignac for this comprehensive portrait of the city at the time of its radical transformation into a modern metropolis.

De Salignac's most obvious predecessor might be Eugène Atget, who over thirty years produced eighty-five hundred glass plates of Paris. But Atget's Paris was already an anachronism, whereas de Salignac's photographs would have seemed very contemporary in their time. A more tantalizing link is to Berenice Abbott, who brought Atget's archive to New York in 1929. She soon set about making her own record of the city: in 1935 she received money from the WPA Federal Art Project and over the next four years produced her book *Changing New York*. We most likely will never know if Abbott encountered de Salignac in the early 1930s when they were both working on the streets of New York, or if she saw his photographs in the New York offices of the Federal Writers' Project (though she surely would have seen the one used in *New York Panorama*). It is tempting to imagine de Salignac passing the torch, or at least a few friendly words of advice, but there is no indication that he ever interacted with any other photographers.

On November 4, 1943, the Museum of Modern Art, acknowledging the recognition of photography as a serious art, opened its new photography center with an exhibition of work by Alfred Stieglitz, Paul Strand, Ansel Adams, Berenice Abbott, Eugène Atget, Mathew Brady, and Edward Weston. The opening was announced in that day's *New York Times*, which also contained a simple obituary notice, "De Salignac — Eugene, suddenly, on Nov. 1, 1943, at the home of his daughter, Mrs. Alonzo Richards." For thirty years de Salignac had worked tirelessly, bringing artistry to even his most mundane daily assignments. His architectural photographs inspire awe, and his photographs of people, compassion. His assignments may have been straightforward, but he produced work of lasting importance and beauty.

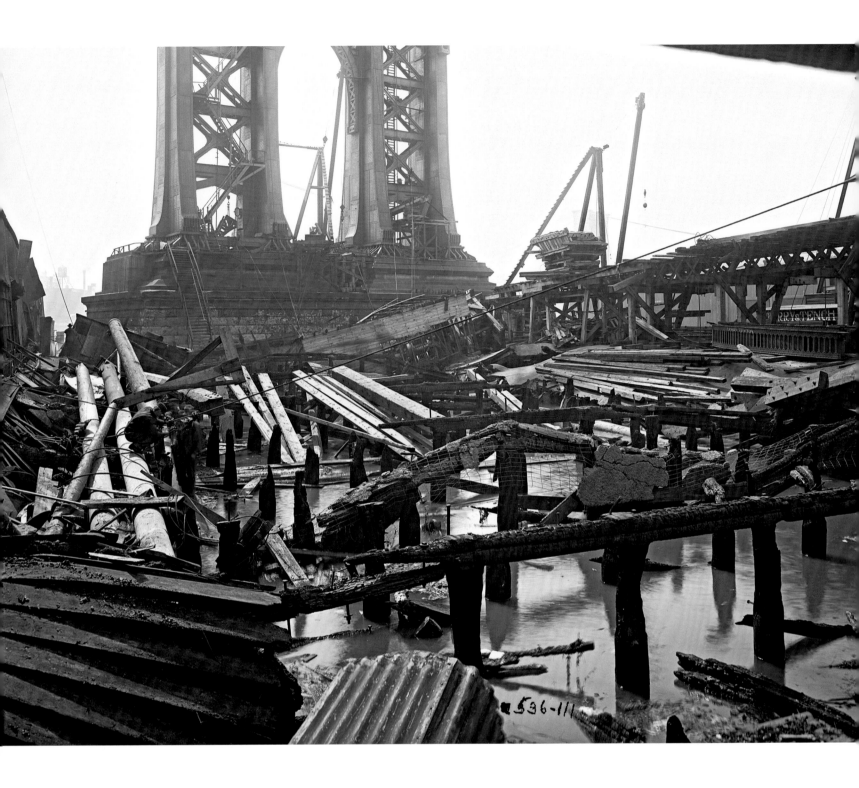

Manhattan Bridge, showing damage by fire,
looking east, April 1, 1908

A RAGGED ORDER

KEVIN MOORE

In his sprawling novels of the 1930s, published in 1938 as the *U.S.A. Trilogy*, John Dos Passos captured the tumult of American life during the first three decades of the century. To both harness and enlarge upon his unruly subject, he developed an innovative narrative style, threading three independent sequences through the stories. One of these sequences he called the "Camera Eye" — flashes of insight that interrupt the novels' grand narrative with stream-of-consciousness impressions: "shrieking streetcar wheels rattling," "cats the color of hot milk," and the smell of "puddlewater willowbuds." More than simply adding another voice to the cacophony, the Camera Eye filtered the period's sights and sounds through a singularly personal point of view. The result was not only a historically accurate view of the United States, but the transformation of observation into art — the U.S.A. seen through a temperament.

For a photographer in the New York City civil service, the personal and the professional were similarly intertwined. Neither impulse could be pure, for the person was always there, as live witness, chronicling the surges of progress. Eugene de Salignac was hired by the Department of Bridges to photograph specific construction sites, new technologies, damaged streets, and bridge-related accidents, and his photographs duly catalog these subjects across a thirty-year span. They also represent something much more individual: a personal history of vision. This is not the usual claim about photographic form or polyvalence — about an individual style or multiple meanings attached to a single subject — but something more specific and physical: the sensations registered in one pair of eyes at precise moments in time and space. In addition to being urban documents, de Salignac's photographs are retinal captures, the elaborate optical diary of a man about whom we know, paradoxically, almost nothing.

What did de Salignac see? He saw bridges and buildings rising, but he also saw them cracking, burning, and in some cases, collapsing; his photographs chronicle New York's ascent, but also the epic mess generated along the way. He saw the hard labor of workers welding and riveting, climbing up cables and scaffolding, and descending into caissons. The portraits are sympathetic, no doubt because de Salignac was a kind of laborer himself. Lugging his large camera to the tops of towers or down into the muck of drainage ditches, he attempted to frame something legible out of the

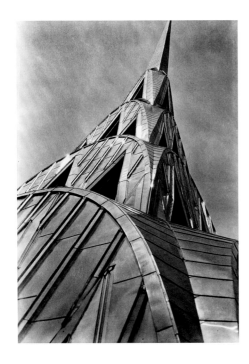

Margaret Bourke-White (1906–1971),
Chrysler Building: Tower, **1931. Gelatin-silver
print, 5 ½ x 3 ¾ in. (13.9 x 9.5 cm)**

chaos of timbers, cables, equipment, and debris that appeared on his camera's ground glass. Rarely has there been such a thorough documentation of the struggle between form and formlessness being played out in the creation of a modern city. Up close, the effort looks more hectic than heroic; one comprehends immediately, gazing through de Salignac's "camera eye," that these marvels of modern engineering were, on a most basic level, the work of hooks and hammers.

Cities had been built before, of course, and sometimes photographed, but not on this scale. The closest parallel is Paris, "Haussmannized" during the last half of the nineteenth century, with its labyrinth of winding medieval streets cut like a pie into triangular wedges. Numerous photographers, such as Charles Marville and Louis-Emile Durandelle, documented aspects of that transformation, but it was controversial from the start, and the resulting photographs are more melancholy tone poems than elegies to "great works."

By contrast, New York in 1900 was an economic free-for-all, and whatever preservationist sentiment existed — for saving the trees and fields, for example, that remained in some of the boroughs well into the twentieth century — was heedlessly ignored. It was a city of big ideas and innovative new engineering techniques, and there were swarms of immigrant laborers ready to carry out even the most visionary of proposals. In the popular imagination, it is the skyscrapers, many of which were built during the 1920s and '30s, that form the vision of modern New York as a city of soaring ambition: the Woolworth, Chrysler, and Empire State buildings express to perfection the masculine hubris of the capitalist idea (above). They are visual

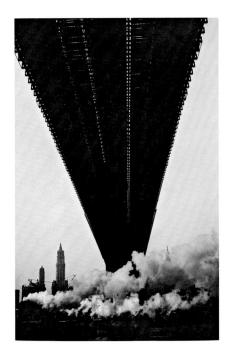

Walker Evans (1903–1975), [Brooklyn Bridge, New York], 1929, printed ca. 1970. Gelatin-silver print, 9 ¹¹⁄₁₆ x 6 ⅜ in. (24.6 x 16.2 cm)

THE METROPOLITAN MUSEUM OF ART, NEW YORK; GIFT OF ARNOLD H. CRANE, 1972, 1972.742.1. © WALKER EVANS ARCHIVE, THE METROPOLITAN MUSEUM OF ART

equivalents to the hammering, slashing chords of George Gershwin's *Rhapsody in Blue*, which in turn echoed the hammering and slashing of work sites and shoes hitting pavement — the sound of ecstatic progress.

Bridges presented a different sort of icon. Bridges were a part of infrastructure, connecting roadways to railway stations and other forms of transportation; they made the city function but without a lot of fanfare. No doubt the experience of crossing a bridge in 1909 was more thrilling to most people than just looking at one (see pages 84–85). Bridges were public spaces that took people up above the buildings and the river, where the air was better and the views unchallenged. Some bridges were monumental, and even sublime, but it was a sublime tinged with a sense of displacement. Bridges invoke the romance of travel, of departures and voyages into the unknown. Hart Crane, one of modernism's most tormented self-destructives, cast a shadow across the modern city with a series of biting meditations on the Brooklyn Bridge, published as *The Bridge* in 1930. For Crane, the bridge invoked feelings of longing, alienation, and the passage of time. Elongated overhead, as pictured in Walker Evans's photographs (above) that accompanied Crane's poem, the bridge becomes a symbol of manic, unguided progress — a launch into the void:

> Out of some subway scuttle, cell or loft
> A bedlamite speeds to thy parapets,
> Tilting there momently, shrill shirt ballooning,
> A jest falls from the speechless caravan.

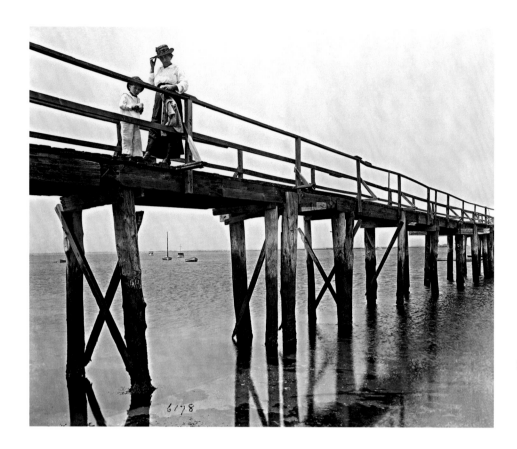

Bridge Pier, Rockaway Point, July 29, 1920

De Salignac seems to have approached his subjects systematically. His photographs of bridges mimic the rational process of their construction, showing the work at every stage, from footings to towers to the crowds on opening day. But the pictures show something larger than a narrative of urban development: they show debris and damage; weary, dirty workers and animals; and dangerous machinery, as well as atmospheric views of the completed structures — in other words, all the mess and all the romance. And romantic many of the pictures are, especially those that depict the mess. A photograph of the Manhattan Bridge, taken on April Fool's Day, 1908, documents the aftereffects of a fire (page 20). Blackened posts, sheets of corrugated tin, and steel girders shatter the foreground, while in the background, one of the towers rises like an ancient ruin. For centuries, artists have depicted new structures of their day as imagined in a state of ruin, perversely looking ahead to the collapse of civilization. One hundred years after its making, de Salignac's picture seems to prophecy both the rise and fall of the industrial age. Another image (page 63) shows a nobler view of the same tower, its top now silhouetted against the sky, but the incompleteness of the structure and its placement among dark warehouses and power lines has the same "future ruin" sensibility — the gravestone of an approaching age.

Several times in the national census, de Salignac listed his occupation as "engineer." (In other places, he appears as "photographer" or "commercial

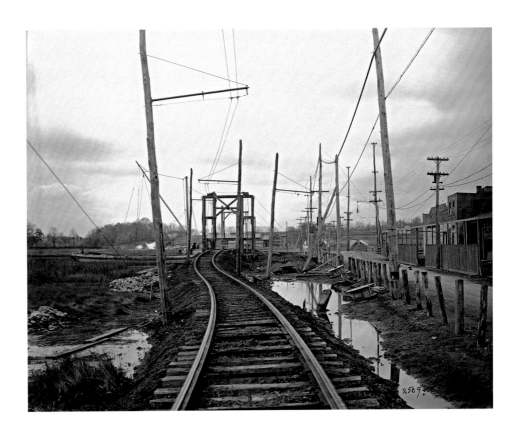

Little Neck Bridge, Queens, view looking southwest, November 28, 1910

photographer.") He was probably just referring to his position as a photographer in the engineering wing of the Department of Bridges/Plant and Structures. Or he might really have been trained as an engineer. No one seems to know. In de Salignac's day, photography — the kind he practiced, anyway — was a more technological affair, requiring an intimate knowledge of camera mechanics and darkroom chemistry. De Salignac apparently got a late start. Divorced at forty, looking for a new life in Manhattan, he seems to have landed in the engineering department almost by accident. Perhaps he had a propensity for technology and answered an ad for a photographer's assistant. However it happened, he became a photographer at a moment when the field of professional photography was changing and expanding. Advances in printing technologies suddenly allowed for the reproduction of photographs in magazines and newspapers, sparking the profession of photojournalism. There were, of course, many amateur photographers running around at that time — both Kodak-wielding amateurs and amateurs with artistic pretensions, some earning the title Pictorialist. Because of his technical skill, de Salignac would have been more closely related to the latter group, which used the large glass-plate technology for its superior quality.

As a professional, he also clearly understood basic pictorial tenets, such as composition and artistic lighting. Many of de Salignac's photographs show a technical and aesthetic proficiency with backlighting (page 55), a recurring subject in numerous articles appearing in photography journals at the time. His photographs

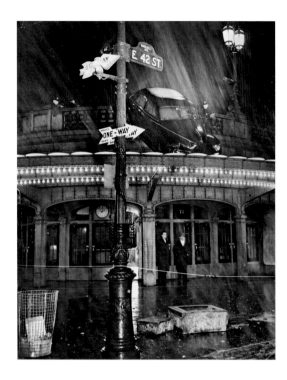

Weegee (Arthur Felig) (1899–1968),
***Wrong Way*, 1944**

also demonstrate a confident understanding of beaux arts rules for composition. Textbook examples, such as the elegant Bridge Pier, Rockaway Point, 1920 (page 24), or the abject Little Neck Bridge, Queens, 1910 (page 25), show a masterful, if conventional, handling of volumes and voids. Fortunately, most of his other pictures are far less predictable.

It is easy now to regard de Salignac's "oeuvre" as a record for posterity, a monument to an era of radical urban change, but it was created primarily as an aid to efficiency. Minutes from a city board meeting in 1934 describe a broad range of practical uses for official photographs: "During the year 1933, photographs were taken for the Mayor's Committee on Receptions to Distinguished Guests, the Mayor's Office, Art Commission, Department of Docks, etc., and in accident cases for the Department of Public Welfare, Department of Parks, and the Corporation Counsel for use in connection with litigation against the City." Public relations, inventory records, legal documents — recorded here is the rationalizing attitude of an archival mindset. Yet such divisions and categories, like the geometry imposed by new streets and steel girders, lend only a semblance of order to a city that was anything but orderly. De Salignac's photographs embody this delusion, organizing the chaos within the camera's viewfinder and in the finished prints. Nowhere is this tension more apparent than in the photographs of Gotham's messier occurrences: the accidents.

One mysterious example, from 1926, shows the interior of a trolley car with bashed-in windows and ghostlike passengers (page 109) — why are they still sitting there? The caption tells us that the site is the Williamsburg Bridge, explaining why the passengers cannot evacuate, but how did the photographer get there? In

instances such as this, de Salignac seems to be a kind of proto-Weegee (opposite), an ambulance chaser, documenting the scene before life returns to normal. Another example, occurring on the Williamsburg Bridge three years earlier, shows a horse cart crashed at the bottom of a roadway, while an "auto truck," caught by the arm of a trolley-car cable, dangles precariously above (page 28). Compounding the complexity of this tense scene, the photographer has waited for a train to pass by on the upper platform, suggesting a hierarchy of competing modes of transportation. One final example, taken in 1933, shows a barge sinking in an industrial wasteland (page 113), a forlorn symbol of the country's industrial collapse.

While de Salignac's pictures are clearly positivistic in their official use as aids to progress, there also seems to be something genuinely subversive in them — in the way he lingers on cracks and imperfections; in his habit of isolating oddities, intensifying their strangeness; in his playful arrangements of workers in relation to the rigid structures on which they toil. There is also something romantic and dark in de Salignac's apparent love of dramatic light and fleeting atmospheric effects — steam blasting behind a man standing next to a tree guard prototype (page 125); a welder nearly consumed in a cascade of sparks (page 126); the glow of bare bulbs outside a "Garcia Grande" cigar and orange drink stand (page 98); rays of light striking the backs of sand shovelers, de Salignac's version of Gustave Courbet's painting *The Stone Breakers* (page 123). A grim portrait of a laborer in the William Street subway cut has all the noirish claustrophobia of an Orson Welles film (page 141). I want to say that de Salignac was a loner, perhaps even a drunk or a cynic, or at the very least a man with a black sense of humor; but maybe, as with Mozart, the man and the work had little in common.

Let me try, in any case, to make my point. One extraordinary picture shows an abandoned lunch stand under the Williamsburg Bridge (page 118). "Arrow," we presume, was part of the name, but this is now mostly obliterated by a sign, posted by the city, announcing the opening of a new trolley line. That sign would be de Salignac's overt subject, but there is much more going on here: a homeless old woman; a mosaic of faded advertisements and awnings; a graffiti image of a snowman; and, most important, a generous foreground encompassing a flagstone pattern of cracks

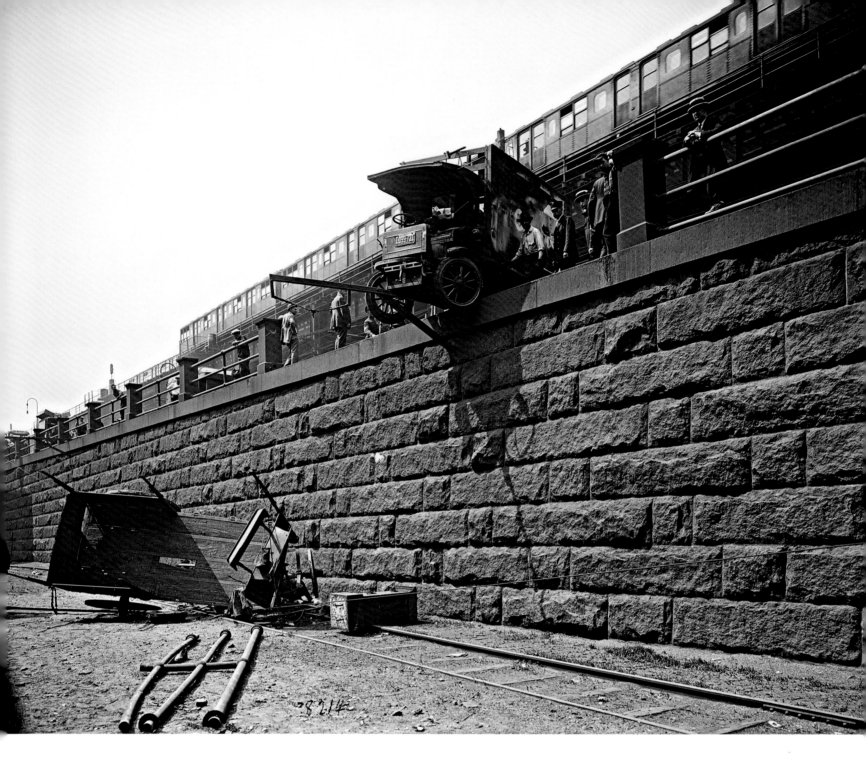

Williamsburg Bridge, view showing auto
truck, south roadway between Bedford and
Driggs Avenue, Brooklyn, June 5, 1923

and stains. De Salignac seems to be promoting, or at least drawn to, an idea of Old New York. Indeed, many of his photographs, ostensibly focused on some aspect of the new, seem more devoted to decay, deformity, and decrepitude — crumbs of the old — such as another dismal, cracked sidewalk under the Williamsburg Bridge (page 119); shadows cast by the Brooklyn Bridge over debris-strewn empty lots (page 43); the disruption of street life on Delancey Street where the Williamsburg Bridge is going in (page 13). In many of these pictures, hard times is the legitimate subject, as in a furtive portrait of a hollow-eyed man, taken on a ferry during the Depression (page 117). In others, cracks and other imperfections suggest an aesthetic preference. One of the drollest pictures in this group shows two ladies at a mayor's committee meeting (page 137), their elegance and dignity of purpose offset by a significant crack in the wall behind them and a reproduction of Gilbert Stuart's unfinished portrait of George Washington.

One is tempted to assign the term *surreal* to this body of work in order to explain the surprises, oddities, and unexplained phenomena. There is even a sense of the *informe* here — Georges Bataille's term, cast in opposition to the highly rational architecture of the day by Le Corbusier and others — but what of it? We can't say for sure that de Salignac was not a subscriber to *La Révolution surréaliste*, the official organ of the Surrealist movement, or that he did not cavort with Marcel Duchamp and others in France, the native land of the de Salignac family, but my guess is that he didn't. Rather than imagining that de Salignac had discovered the Surrealists, it is more plausible to imagine that the Surrealists had discovered him. Casting around in the waters of pop culture of the time, the Surrealists dredged up a wealth of flotsam — evidence, in their minds, of a particular kind of psychic, urban, bourgeois alienation. In ordinary photographs, most by anonymous photographers, they found the latent uncanny just beneath the surface of ordinary appearances, a kind of beauty that was convulsive, as they conceived of it.

Had he worked in Paris, de Salignac would have been in all likelihood an unwitting contributor to Surrealist publications, producing, as he did, images of bizarre, unexplained objects photographed with no apparent context, such as different sizes of rivets (page 93); snapped and burnt cables with no small amount of sculptural

interest (page 111); crude public graffiti (below); an enormous white letter W (page 45); and suited officials out in the field doing absurd things, like measuring cracks in the street and the distance between rivets (page 91), a send-up of modern society's obsession with precision. The Surrealists would also have loved de Salignac's street scenes — the accidents, certainly, but especially the more ordinary scenes, such as a chance juxtaposition of movie posters for *Ashamed of Parents* and a refreshment stand with a banner reading "All kinds of nuts" (page 98). Even better: ordinary storefronts, such as Wenig Live Fish (page 99), Hoffman House Cigars, and Garcia Grande, once again, provoke a sense of the uncanny with their mass-produced objects, shopkeepers in shadow, and sense of abandonment.

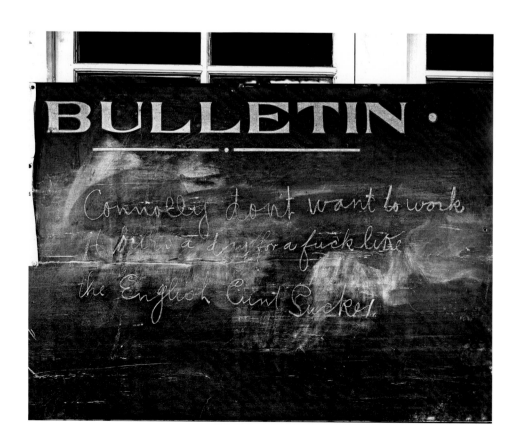

Brooklyn Bridge garage showing writing on bulletin, September 18, 1911

This line of thought leads us inevitably to Atget (below). Certainly, the two Eugenes had much in common. Eugène Atget worked systematically, documenting Paris according to a set of preset categories. Eugene de Salignac was also archival in his approach, and there is even some crossover in categories. Both Eugenes came late to modernism, being advanced in age by the turn of the century, yet both were prescient in their aesthetic judgment, even while remaining devoted to certain sights of the past. Both photographers worked with large glass-plate negatives and cameras that sat on tripods well into the period when smaller, portable, roll-film cameras, such as the Leica and the Ermanox, had overtaken their awkward predecessors. Most important, both photographers worked commercially, providing images for a variety of practical purposes.

Where the two photographers part ways is more a question of chance than intention: de Salignac vanished into obscurity, a hapless author fallen through the

Eugène Atget (1857–1927),
Boulevard de Strasbourg, **1912.**
Albumen print, 8 ¾ x 7 in. (22.5 x 17.8 cm) (trimmed)

COURTESY GEORGE EASTMAN
HOUSE, ROCHESTER, NEW YORK

Berenice Abbott (1898–1991), *Ferry,*
Central Railroad of New Jersey,
1936. Gelatin-silver print, 8 ¾ x
7 ½ in. (22.3 x 19 cm)

cracks of a municipal archive. Atget might just as easily have suffered the same fate
had it not been for the worshipful Berenice Abbott, who after his death in 1927
rescued the prints and negatives, promoted the work in the United States, and
perpetuated the approach in her own accomplished photographs of New York, taken
as self-conscious art (above). In other words, Atget fell right into a tradition of art
photography, already under construction during the 1930s and then renovated during
the 1960s, and he turned out to be a pillar of the medium's history. Who can say if
de Salignac's position would be any different if he had been known earlier, if Stieglitz,
Steichen, the Surrealists, or John Szarkowski, curating in the 1960s, had known the
work and had seen something modern and original in it? Too many temperamental
factors affect the writing of history — more, often, than we care to admit. What is
clear is that de Salignac saw with his own eyes the radical transformation of a small
island, organized and ordered by every means possible at the time, and that even
though his photographs show a ragged process of imperfection and human failure,
the image remains of a city that is lofty and, at times, transcendent.

PLATES

BROOKLYN BRIDGE

The most famous of New York's bridges is, of course, the Brooklyn, which had opened to great fanfare in 1883. Designed by John Augustus Roebling and completed by his son, Washington Roebling, and daughter-in-law, Emily Warren Roebling, it was the longest suspension bridge in the world until the completion of the Williamsburg Bridge in 1903 (which bettered it by just four and a half feet).

The Brooklyn Bridge would be a continual source of inspiration to de Salignac and a constant presence in his work. On September 22, 1914, he photographed a group of painters at work on its lower trusses. He must have had a spark of inspiration that day. Two weeks later he returned and posed the men arrayed on the web of wires like notes on a musical scale (opposite). The photo was obviously planned, because the relaxed and evidently fearless men are not carrying their equipment, and their supervisor seems to have joined them. No vintage print of this iconic photo — the most famous of de Salignac's images — is known to exist.

Brooklyn Bridge, showing painters on suspenders, October 7, 1914

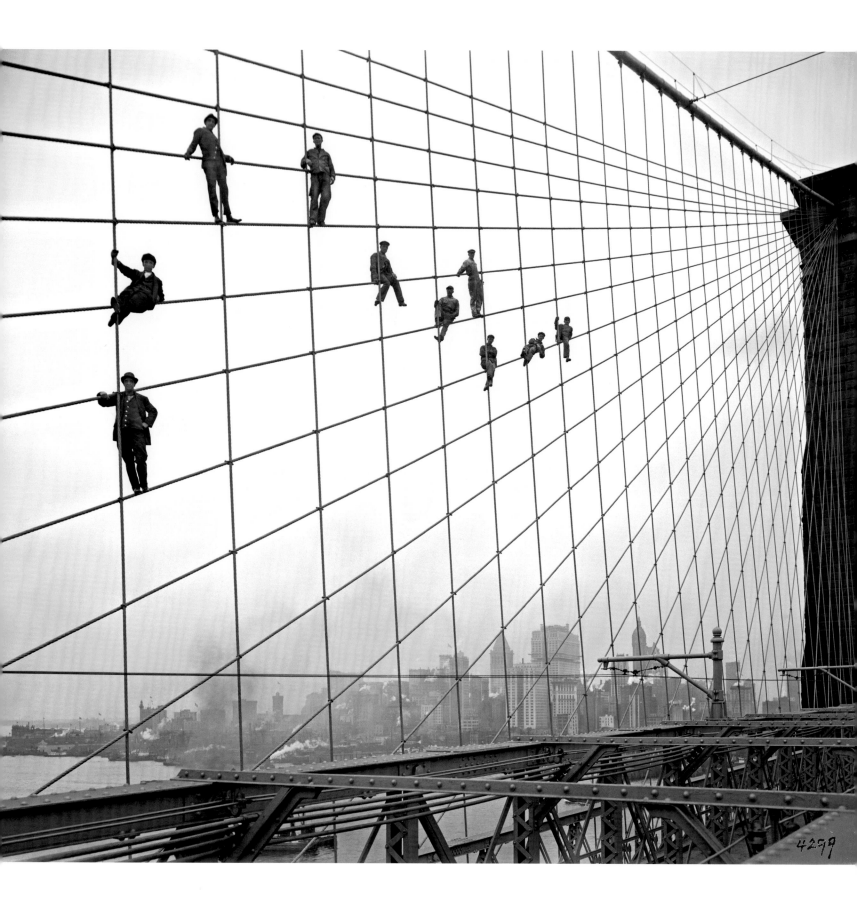

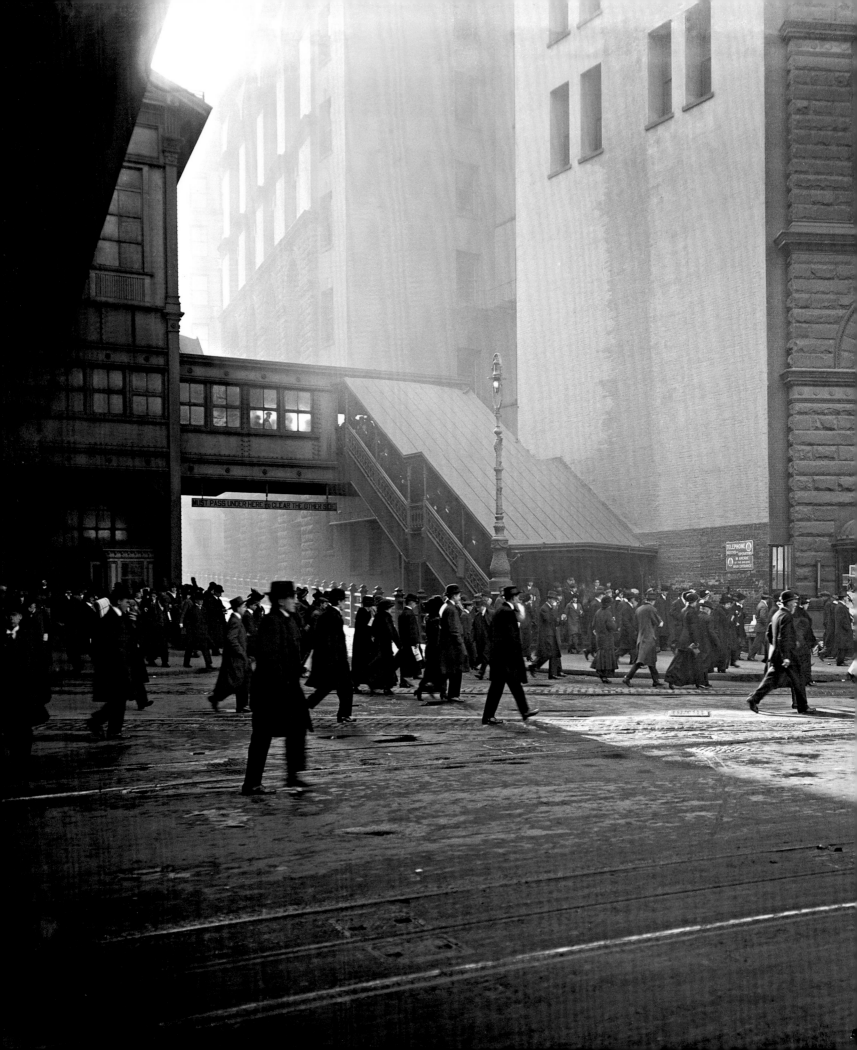

Brooklyn Bridge, New York approach at Park
Row, showing pedestrians, November 12, 1914

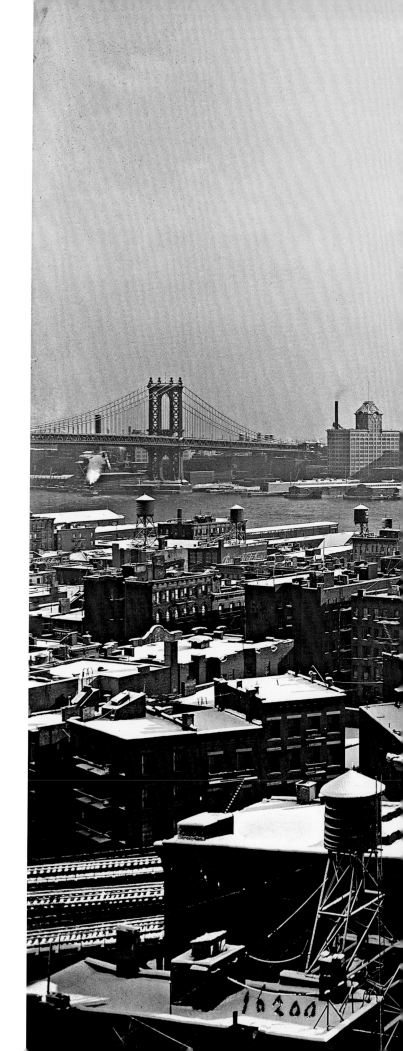

Brooklyn Bridge, showing snow and ice,
February 2, 1934

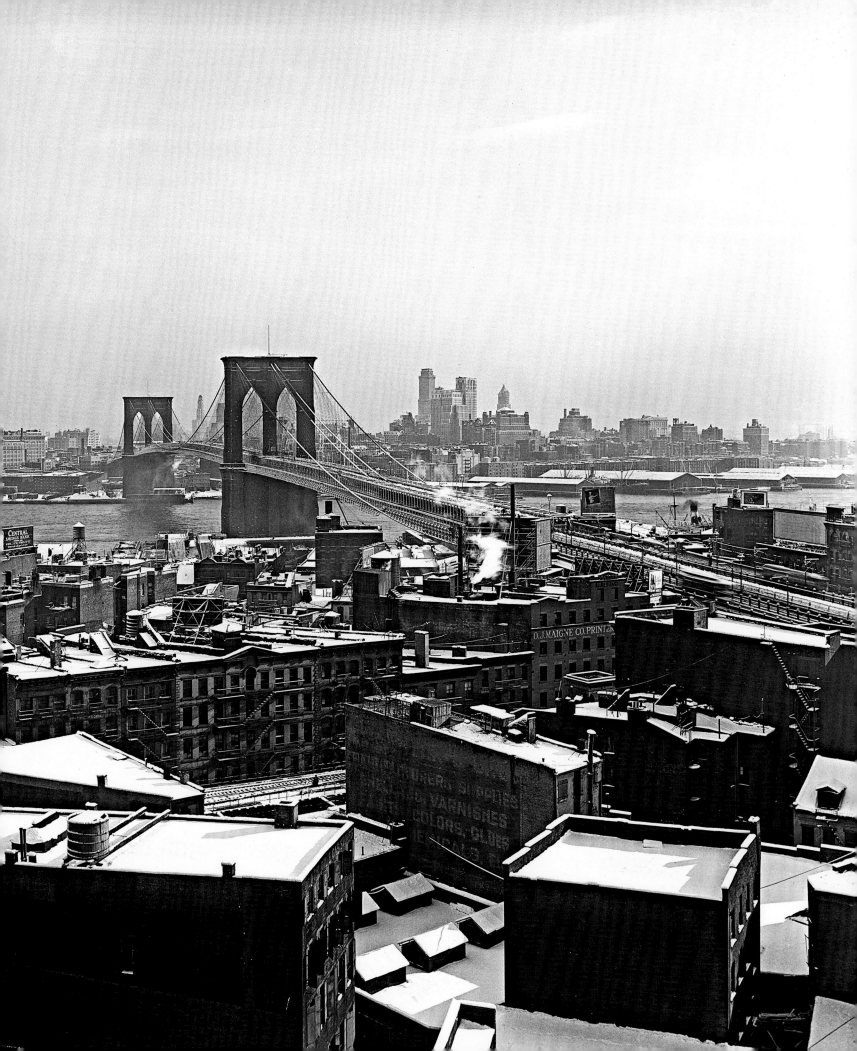

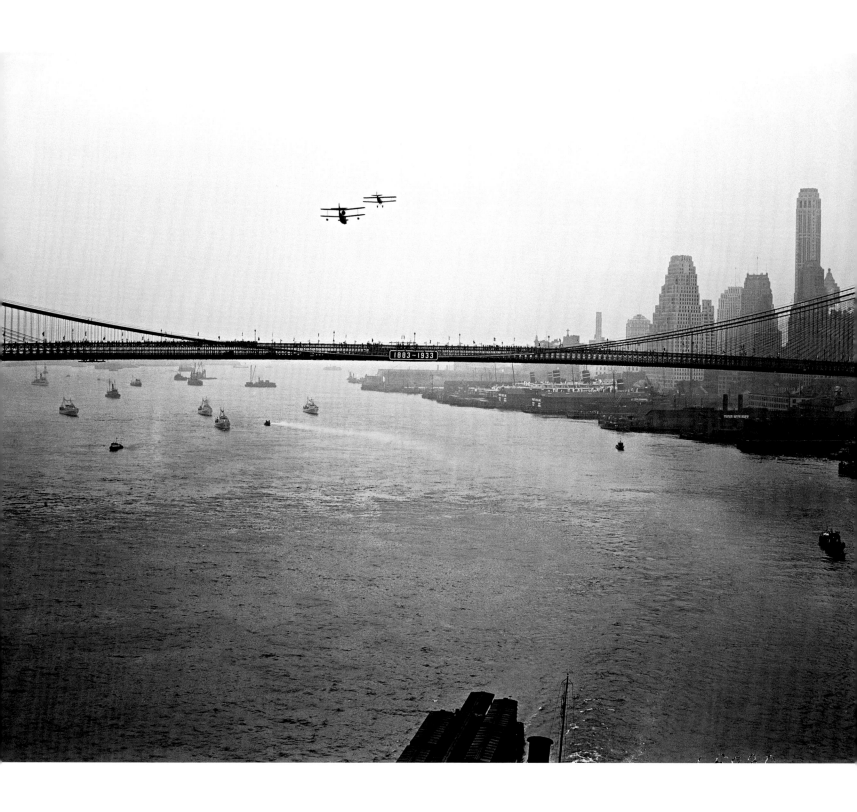

Brooklyn Bridge, 50th Year Anniversary, from Manhattan Bridge, May 24, 1933

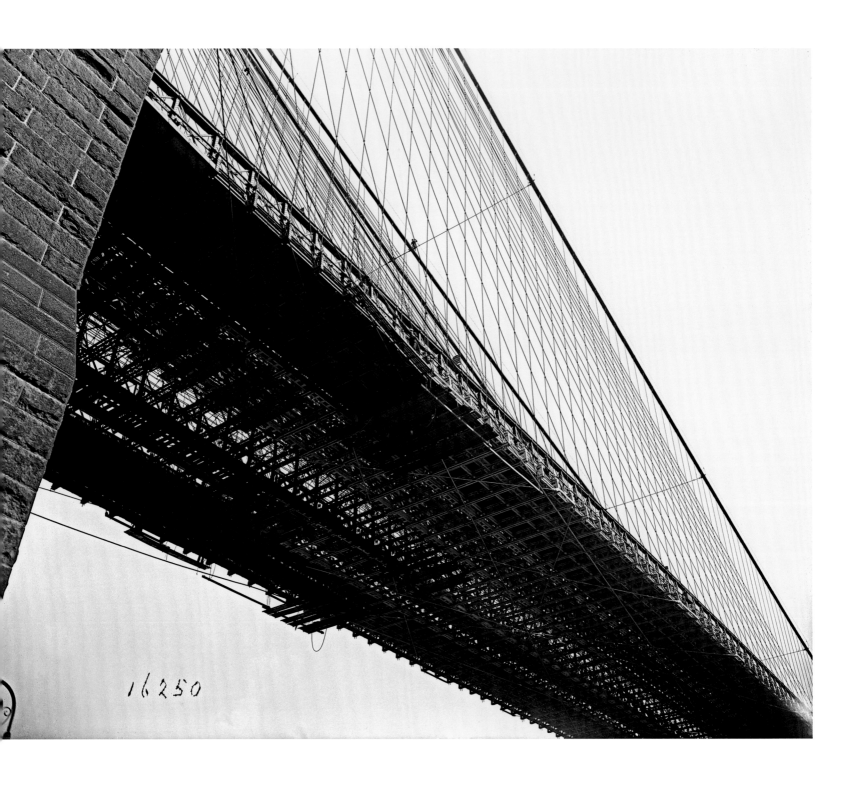

Brooklyn Bridge, showing painters' scaffold,
April 9, 1934

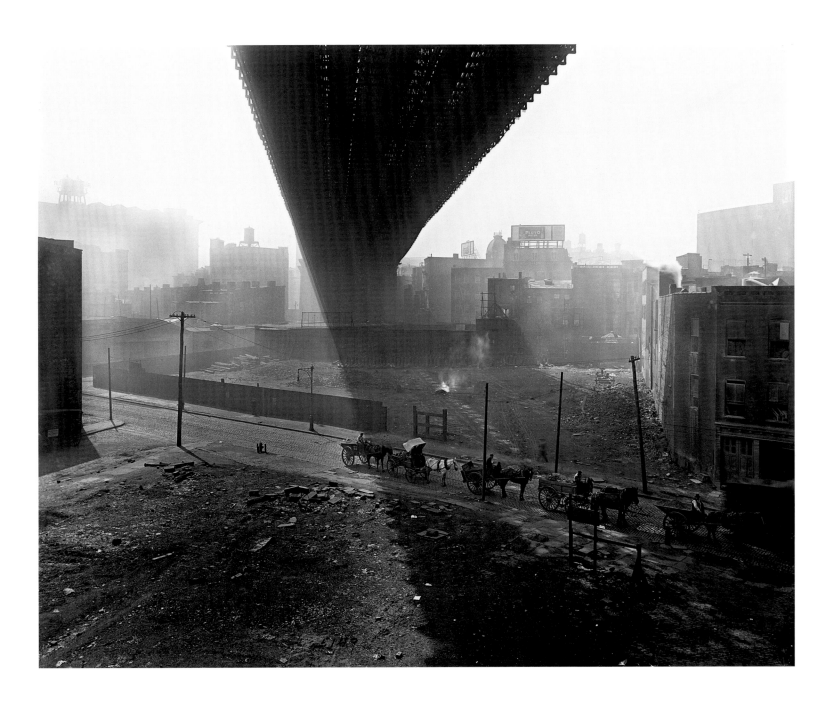

WILLIAMSBURG BRIDGE

The need for a "New East River Bridge" became apparent soon after the Brooklyn Bridge opened. Work on what would become known as the Williamsburg Bridge began in 1896, and it was opened to traffic in December 1903. Although its completion predates de Salignac's first photographs, some of his best photos were made on and around the bridge. One of his most striking compositions records the massive *W* in the yard under the bridge (opposite). The W was not for "Williamsburg," but for "WSS" — War Savings Stamps, a World War I advertisement for savings bonds.

The troubled history of the Williamsburg Bridge gave de Salignac frequent opportunities to photograph diverse construction techniques. Unlike the Brooklyn Bridge cables, which carry its entire length, the main cables of the Williamsburg Bridge support only the center span. The side spans were originally each supported by a steel viaduct. In 1911 engineers noticed that these spans had started to sag under the weight both of increased traffic and of the elevated trains that were added in 1908. The addition of two extra supports per span was completed in 1913.

Construction of the Williamsburg Bridge had a huge impact on the Lower East Side — first a physical impact, as neighborhoods were torn up for the bridge approaches and subway lines, and then a demographic impact, as the Jewish population migrated from the overcrowded tenements of the Lower East Side to the now easily accessible open spaces of Brooklyn. This transition period was well documented by de Salignac. In 1907 and 1908 he photographed daily life along Delancey Street, and the surrounding neighborhood (pages 13 and 98, top left), as it was dug up for the train lines (page 46) that eventually formed the basis of the Brooklyn-Manhattan Transit Corporation, or BMT. This was the only subway line at the time constructed by the city (all others were the domain of private companies), which is why de Salignac photographed the cut-and-cover techniques here and not elsewhere.

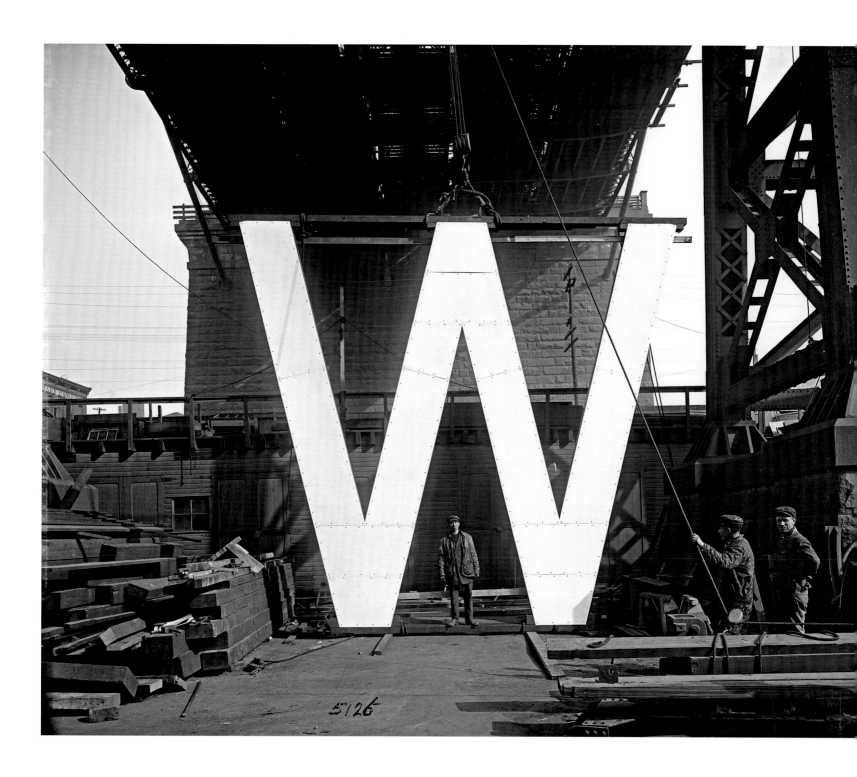

Williamsburg Bridge, view showing Kent Avenue yard "W," 20 feet, for "WSS" to be placed on towers, March 20, 1918
[WSS stands for "War Savings Stamps"; the letters were erected on the south side of the Manhattan tower during World War I.]

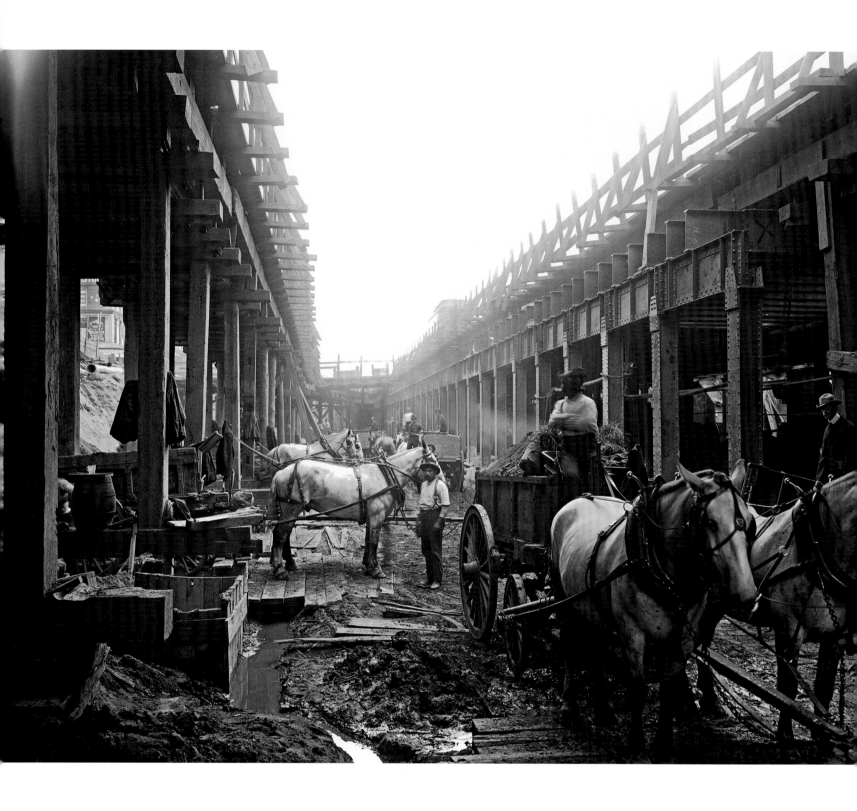

**Looking east into excavation, Delancey
Street subway, August 28, 1907**

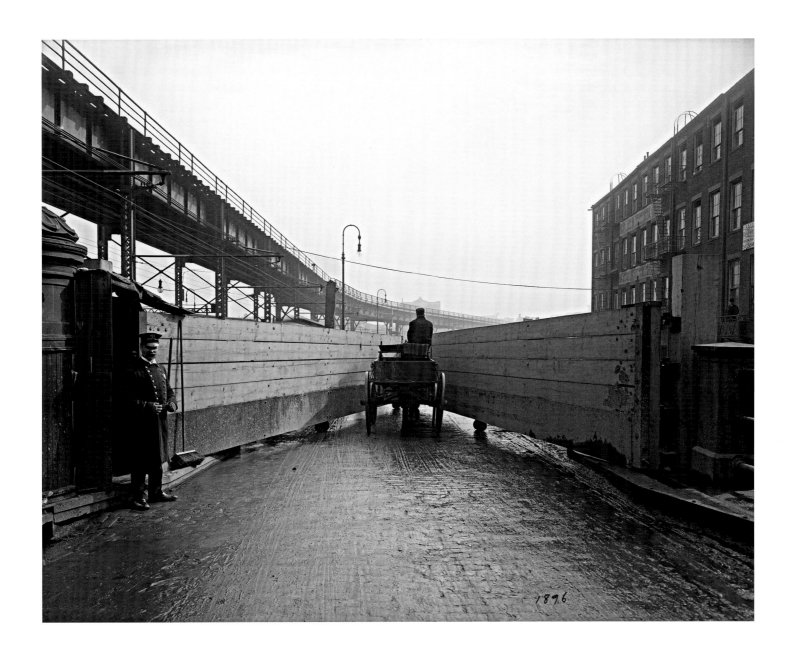

Williamsburg Bridge, showing new gate,
looking east, February 16, 1910

THE QUESTION OF STOPPING RUNAWAY HORSES HAVING BECOME SERIOUS, SOMETIMES
AVERAGING THREE A MONTH (A LARGE PERCENTAGE FATAL TO THE HORSES), AN
ELECTRICALLY OPERATED V-SHAPED BARRIER CONSISTING OF TWO LEAVES WAS
INSTALLED [ON THE WILLIAMSBURG BRIDGE] AND PROVED REMARKABLY SUCCESSFUL IN
STOPPING THE FRIGHTENED ANIMALS WITHOUT INJURY TO THEMSELVES OR DRIVERS.

— Annual report of the Department of Bridges, 1910

CAISSONS

Bridges need towers to support them, and towers need to sit on something solid. How to build a stone tower on a river bottom? The Williamsburg Bridge towers were erected by using the pneumatic caisson, a nineteenth-century engineering marvel pioneered on the Brooklyn Bridge. A caisson is essentially a giant wooden box, open on the bottom and accessed through primitive steel airlocks in the top. Built on land by carpenters and sealed with tar, the caisson would be towed into position and then sunk as the stone tower foundation was built on top of it. And as it sank, pressurized air was pumped in to force the river out. When the caisson reached the riverbed, workers (the original "sandhogs") descended through the airlock and excavated the muck through a separate airlock. When the caisson reached bedrock, cement was pumped into the caisson to support the foundation. Fires, explosions, and toxic air were just a few hazards of the sandhogs' job. The frequent pressure changes in these crude airlocks resulted in a condition known as "caisson's disease," a potentially fatal buildup of nitrogen bubbles in the bloodstream and joints, now known by divers as "the bends." It was caisson's disease that felled Washington Roebling during construction of the Brooklyn Bridge, making him a lifelong invalid.

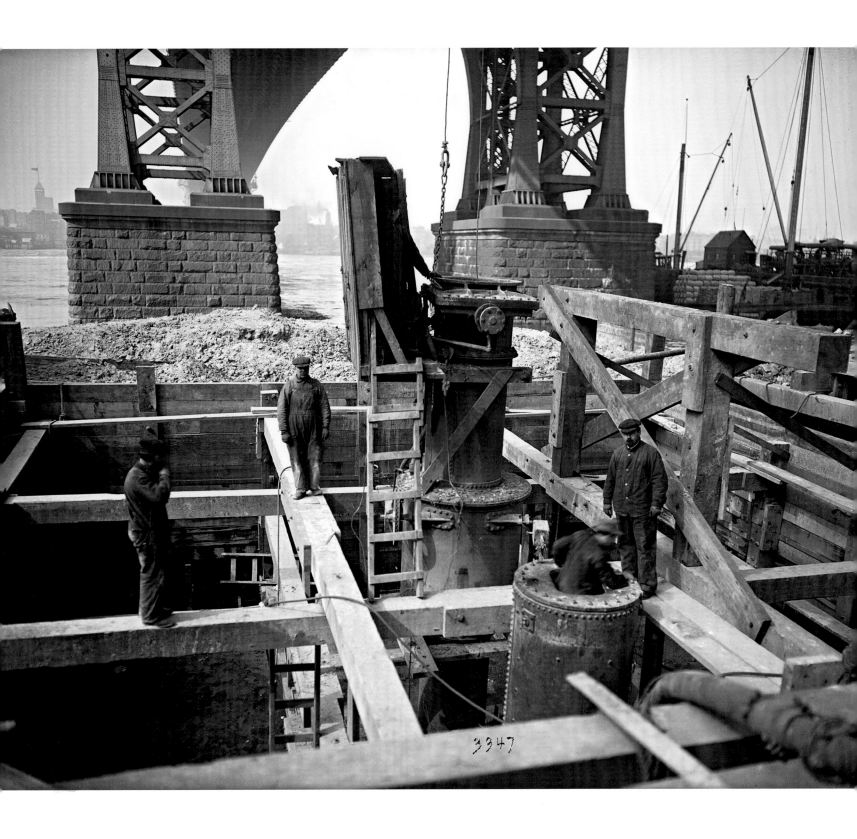

Williamsburg Bridge, Brooklyn side looking
west, showing view of interior of cofferdam
of southern caisson, March 1, 1912

**Williamsburg Bridge Caisson #2, general
view of workers, October 14, 1911**

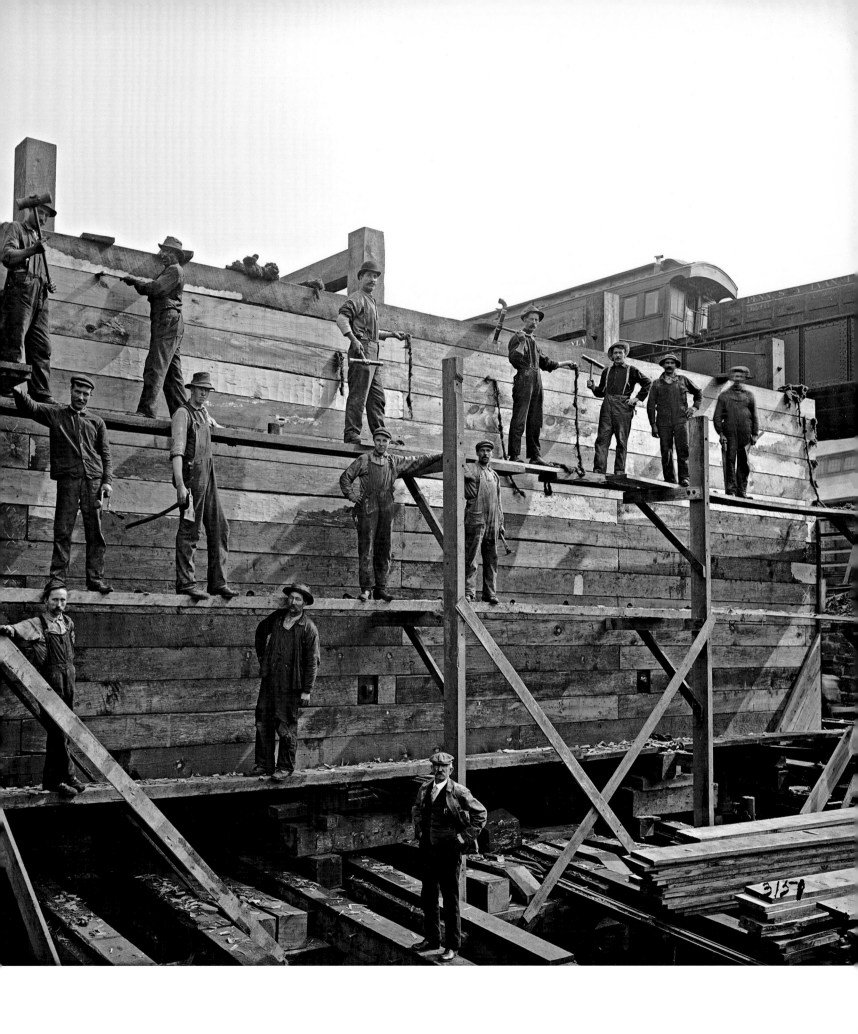

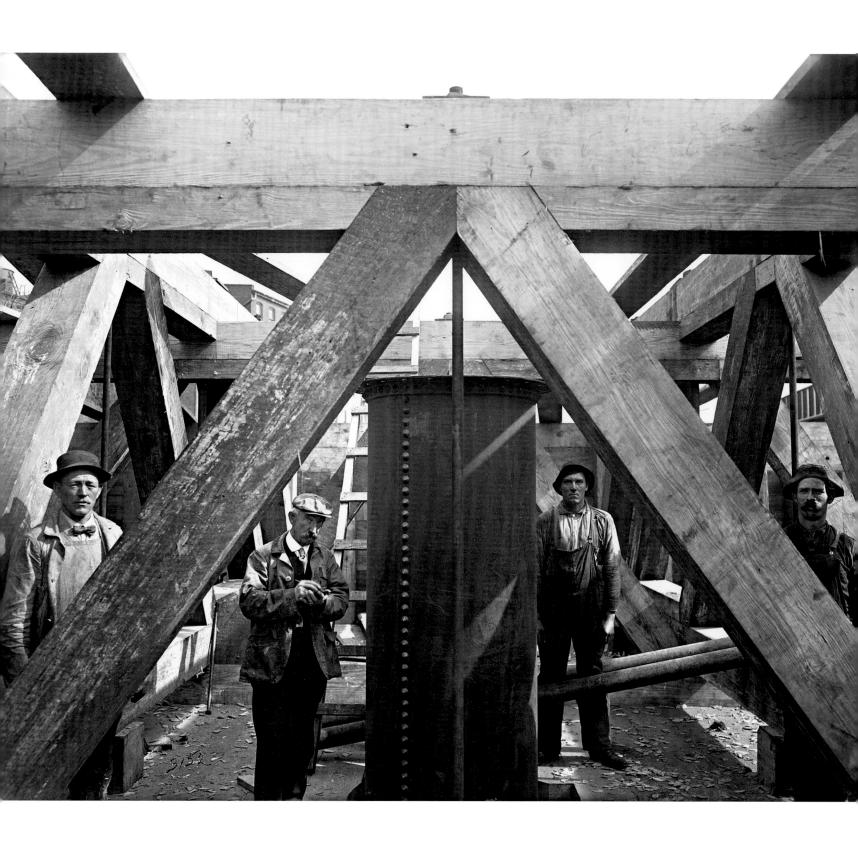

Williamsburg Bridge, Caisson #2, interior
view at airlock, October 14, 1911

CABLES

Leffert L. Buck, chief engineer, had felt it unnecessary to galvanize the main cable wires of the Williamsburg Bridge. This made them less brittle, but more susceptible to rust. Unfortunately, the antidote to the rust was to apply a coat of waterproofing that turned out to be flammable. In 1902 disaster struck when a fire swept through the scaffolding. The March 4, 1903, City Record report of the Department of Bridges notes: "Nearly all the cable bands had been placed on the cables and most of the suspenders were in place, and a large portion of the waterproofing had been applied when the fire occurred, on the evening of November 10, burning the waterproof covering off of the cables . . . and completely wrecking the footbridge." To repair the damage, the cable wires were unwrapped, spliced together, and rewrapped. In subsequent years the cables were treated with oil and other substances and rewrapped again. This is how de Salignac came to photograph a cable spinner at work in his hut in 1918 (opposite) and the oiling of the main cables in 1921 (pages 56–57).

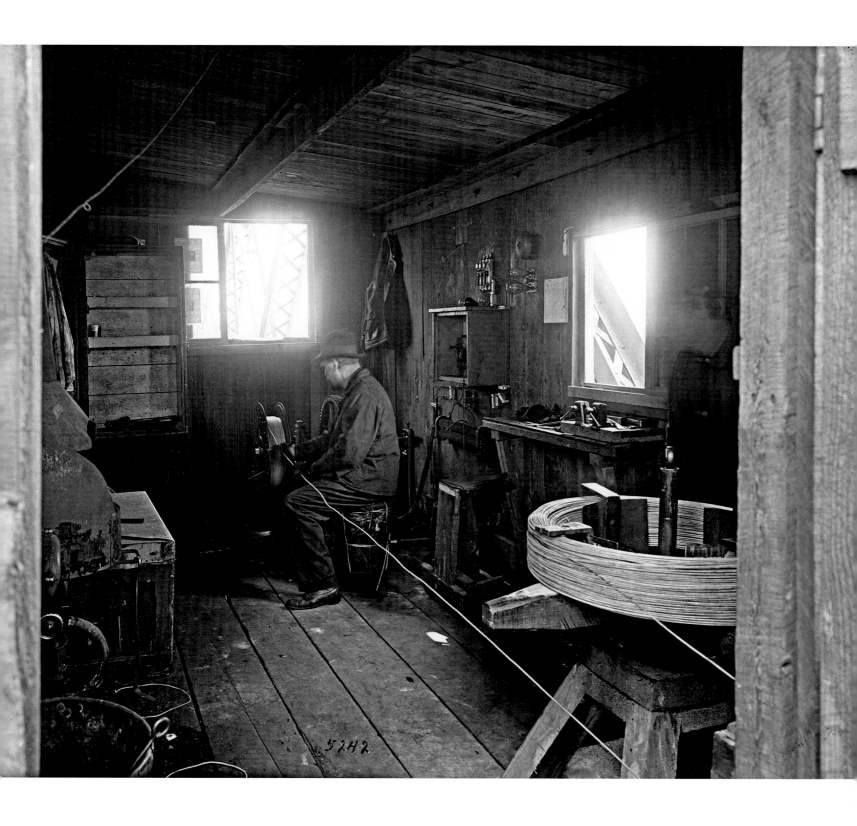

Cable spinner at work in shanty,
Williamsburg Bridge, June 24, 1918

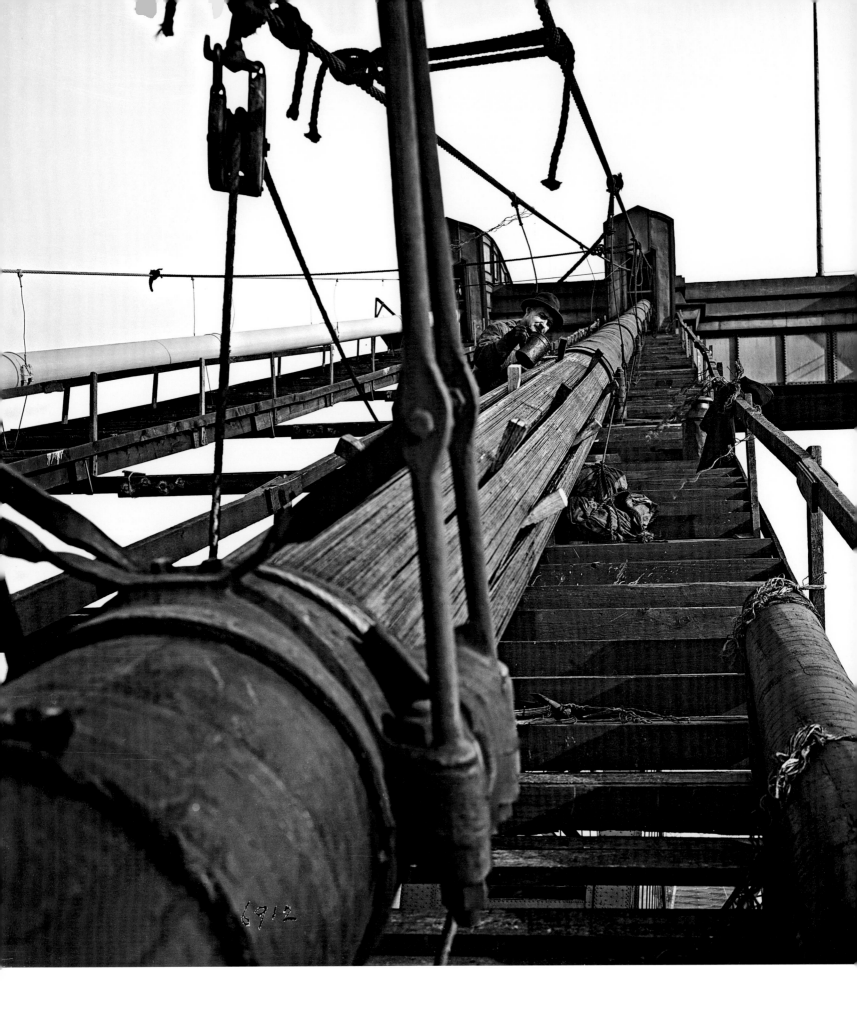

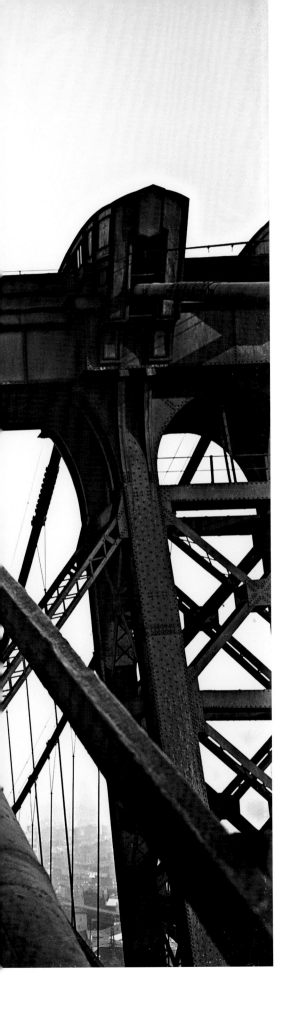

Williamsburg Bridge, view showing oiling
of cable, Manhattan Tower, north cable,
November 16, 1921

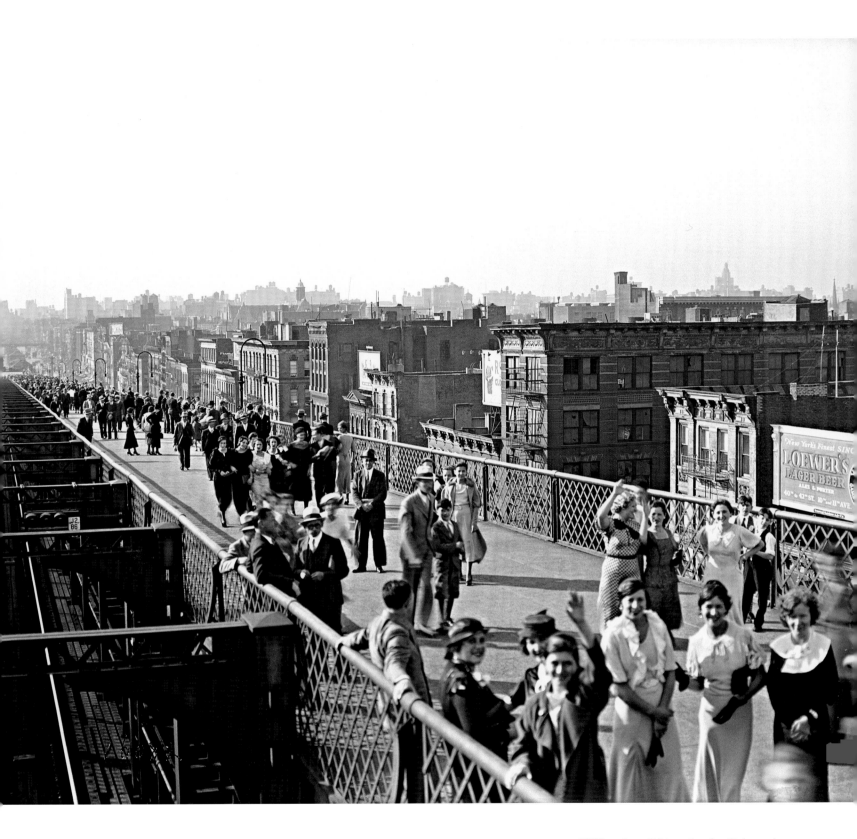

Williamsburg Bridge, showing Hebrew day
of atonement, people on bridge foot walk,
September 30, 1933

MANHATTAN BRIDGE

The "Third East River Bridge" was started in 1901, the same year that the Department of Bridges photography unit was established. However, there were many construction delays and much political infighting — after completion of the Williamsburg Bridge in 1903, many thought a third bridge into Brooklyn was a waste of money. By the time de Salignac started photographing in 1906, only the stone tower bases had been completed, and the anchorages were just half finished (opposite). His office during these years was at 60 Washington Street, just steps away from the bridge's Brooklyn anchorage. From 1906 until the bridge opened in December 1909, he shot over five hundred negatives detailing every step of the construction. When the steel towers were completed, a wooden walkway was strung to the tops for the cable spinners to traverse as they laid the main cables. De Salignac climbed to the top of the Manhattan tower to photograph this first tenuous connection of the shorelines (page 67).

In August 1907, the south arm of the cantilevered Quebec Bridge being built over the Saint Lawrence River collapsed. Seventy-five workers were killed. The company building the bridge was the Phoenix Bridge Company — also at work constructing the steel towers of the Manhattan Bridge. Work on the Manhattan Bridge was immediately halted. The bridge was eventually deemed safe, Phoenix's parent company took over the job, and work continued. All, however, was not right with the bridge. The Manhattan Bridge was the first major suspension bridge to be designed according to deflection theory: the concept that suspension bridges could withstand flexing and that the weight of the cables and dead load of the bridge were stabilizing factors. This would mean that bridges required fewer stiffening trusses (the framework of beams under and around the roadways), which allowed for thinner, sleeker designs. Department of Bridges engineer Leon Moiseiff was a pioneer in this theory. Unfortunately, the technology was still in its infancy, and little was understood about the true stresses on a bridge.

The problems caused by the initial underbuilding of the Manhattan Bridge were compounded by the later decision to run subway trains on the outside of the roadways. The excess torque created by two trains passing from opposite sides caused eight

feet of deflection in the roadway. By 1937 serious problems with the bridge were already apparent, and bids were put out to reinforce the trusses. Only twenty years later, more work was required to fix the cracking steel, followed by more repairs in the 1970s and a major restoration started in the 1990s. But none of this was known in de Salignac's day, and his 2,174 photographs of the bridge glorify the modern steel structure.

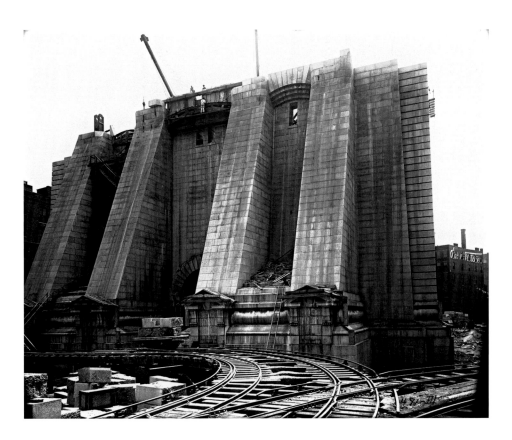

Manhattan Bridge Anchorage, south from schoolhouse shed, Manhattan, September 24, 1907

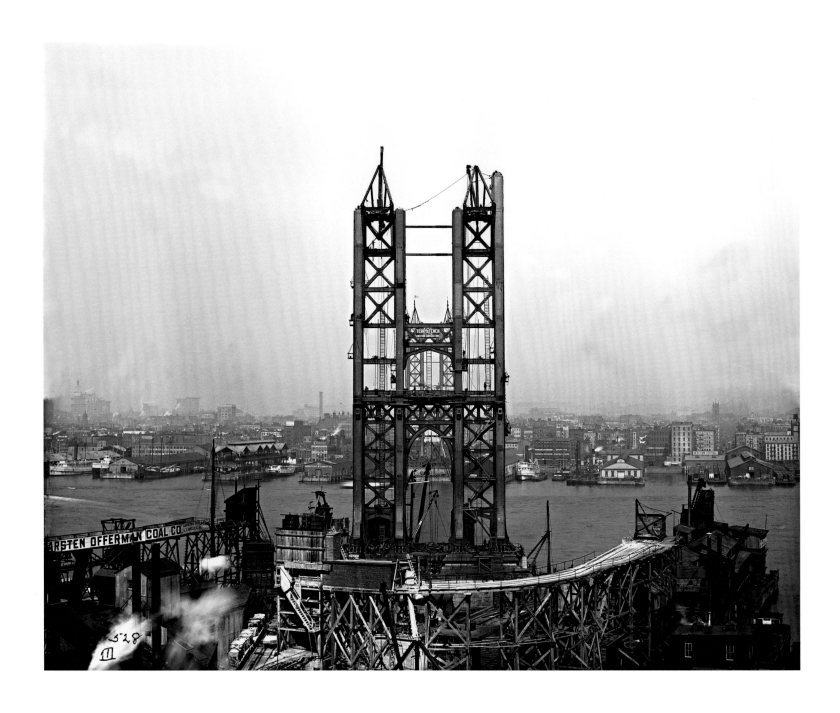

**Manhattan Bridge, from top of anchorage
looking west, Brooklyn, March 12, 1908**

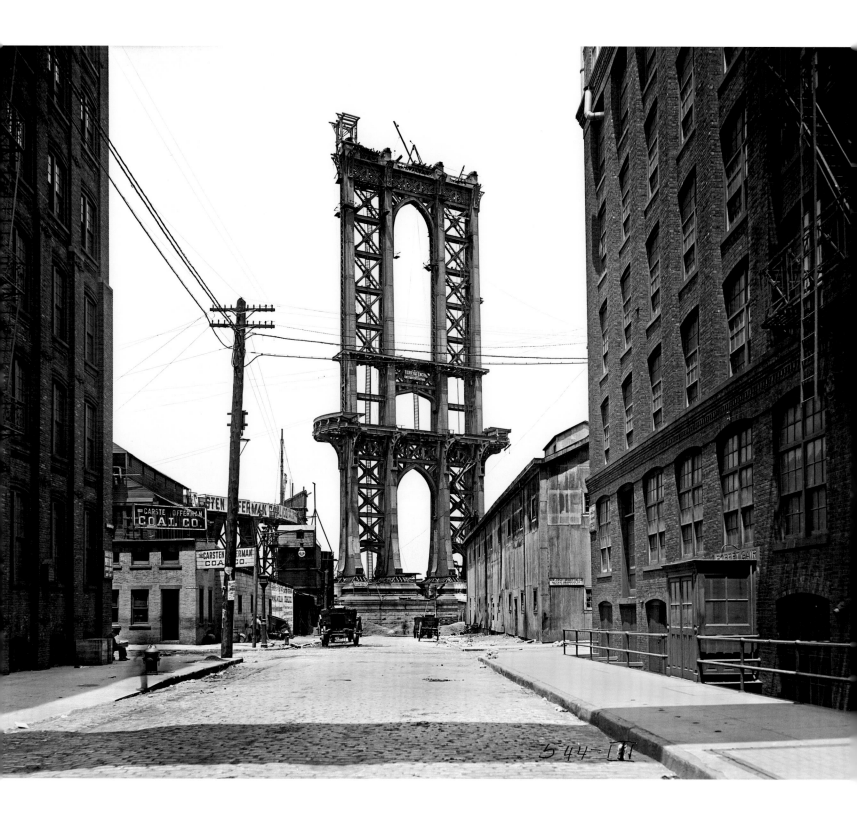

**Manhattan Bridge, from Washington Street
looking west, Brooklyn, June 5, 1908**

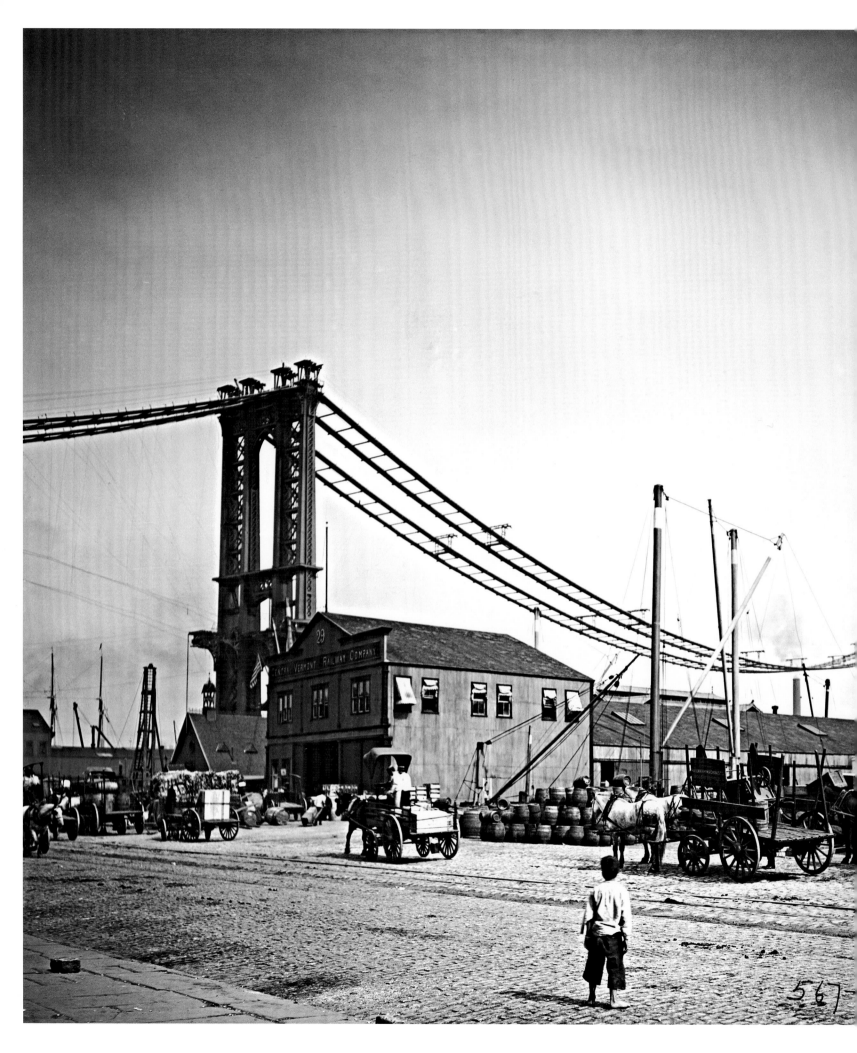

**Manhattan Bridge, looking northeast from
South Street, August 3, 1908**

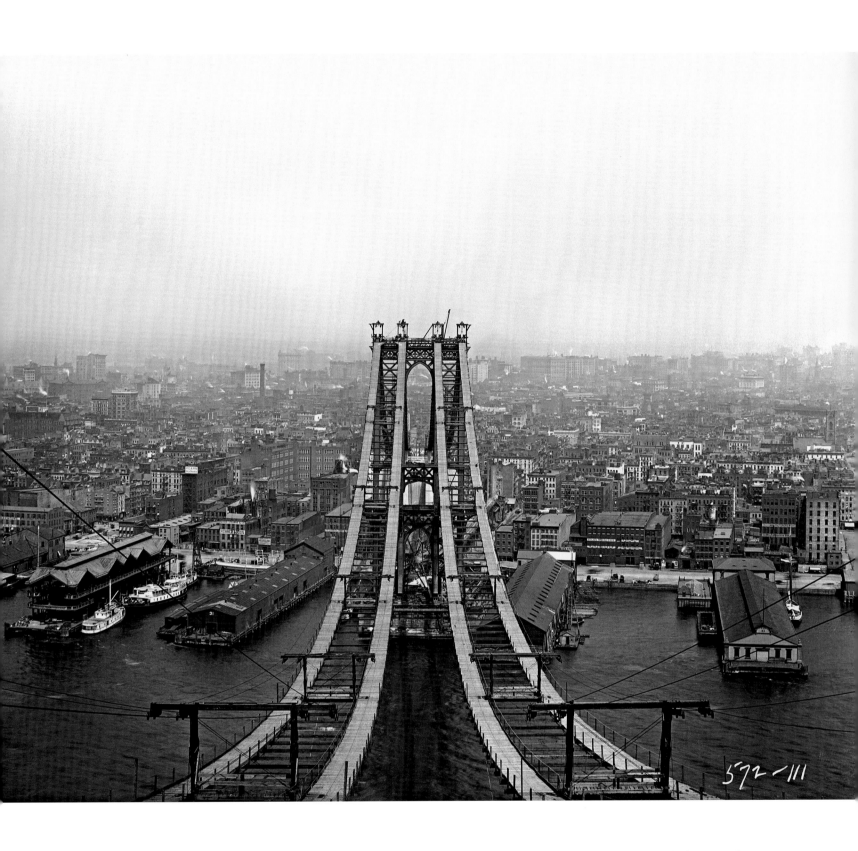

Manhattan Bridge, looking west from
Brooklyn tower showing foot walk,
August 3, 1908

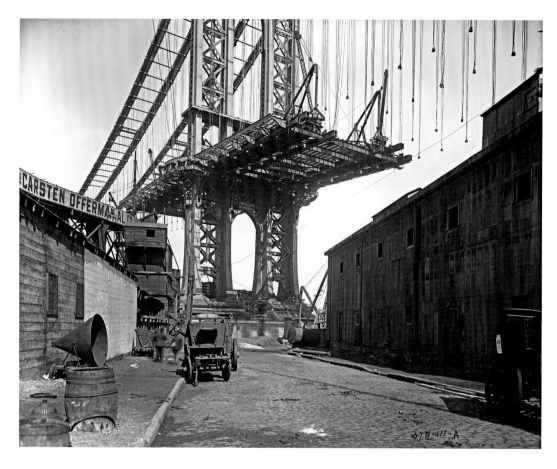

Manhattan Bridge, from
Washington Street, showing
tower, March 17, 1909

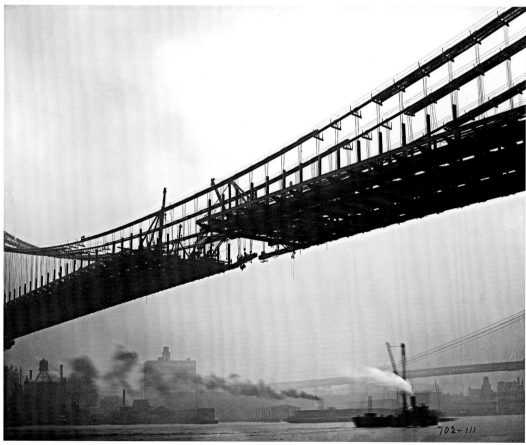

Manhattan Bridge, from Pier 33,
East River looking south, last
cord, April 7, 1909

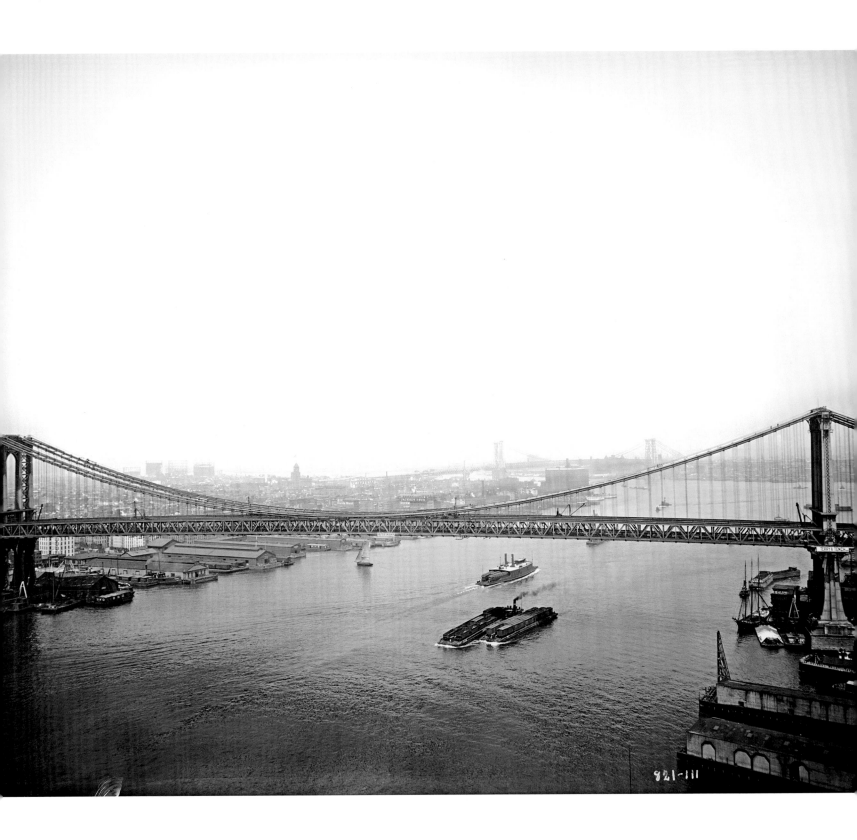

**Manhattan Bridge, from top of Brooklyn
Bridge tower looking north, June 29, 1909**

Manhattan Bridge, looking north on
Manhattan approach, May 29, 1911

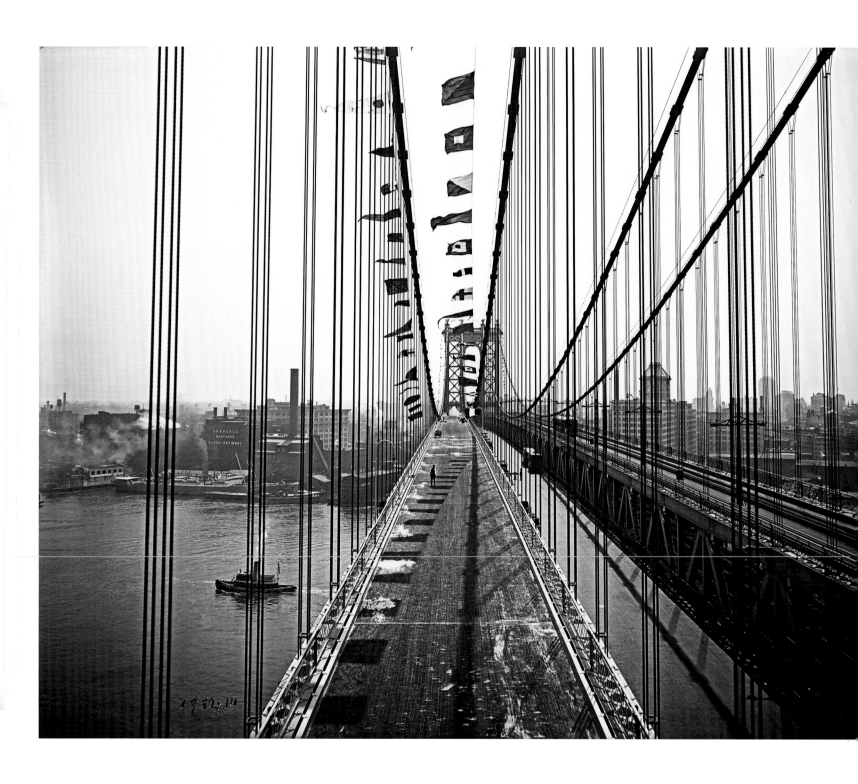

**Manhattan Bridge, from balcony looking
east, Manhattan tower, June 14, 1922**

GUARDING THE BRIDGES

During World War I, fears of sabotage abounded, and the bridges became a source of anxiety. On July 30, 1916, German agents blew up a munitions dump in the harbor near Liberty Island. The explosion blew out windows as far north as Times Square, lodged shrapnel in the Statue of Liberty, and rocked the Brooklyn Bridge. The bridges were guarded by a coalition of forces, including police, army, and coast guard, armed with machine guns and small artillery.

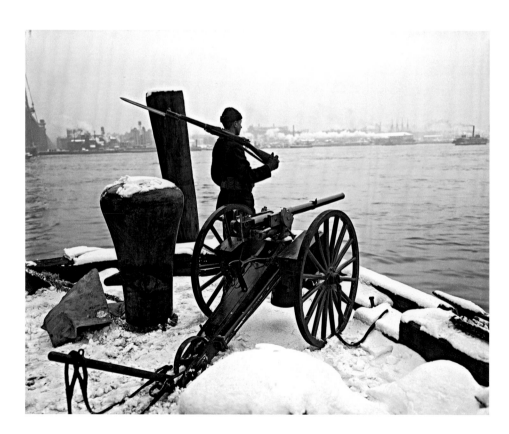

Williamsburg Bridge, showing Coast Guard artillery, Brooklyn, March 3, 1917

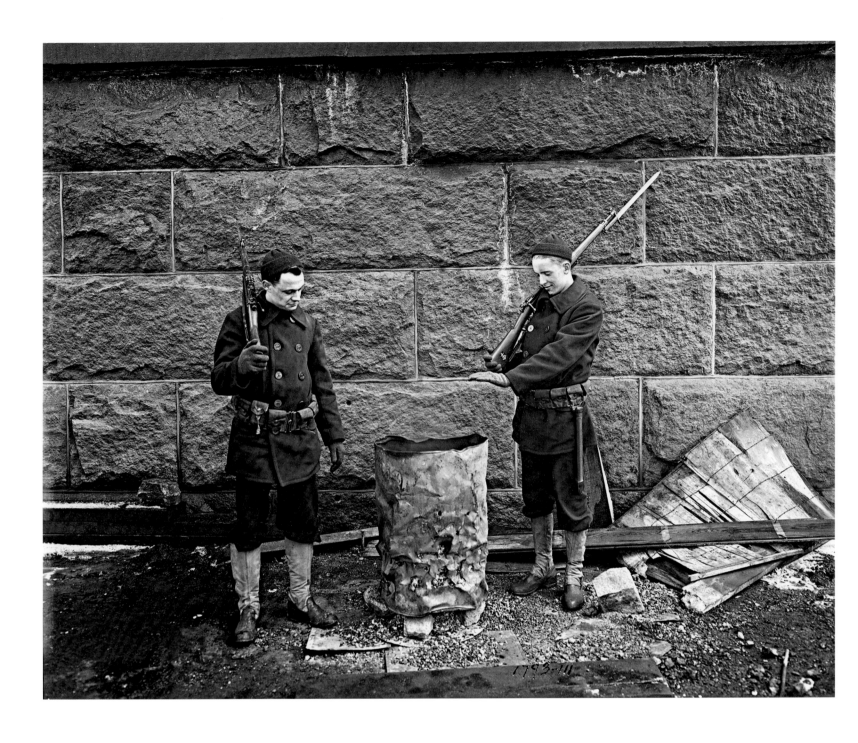

Manhattan Bridge, showing Coast Guard
artillery, March 3, 1917

QUEENSBORO BRIDGE

Construction of the Queensboro Bridge — linking Manhattan with Long Island, using Blackwell's Island (now Roosevelt Island) as a junction — was almost concurrent with the Manhattan Bridge, but the Queensboro was finished nine months earlier. The bridge was further along when de Salignac began photographing it, but he still logged seven hundred negatives of its initial construction and over twenty-three hundred photographs related to it. The first nonsuspension bridge over the East River, it is one of the greatest cantilever bridges ever constructed, with a total length of 7,449 feet. Noted engineer Gustav Lindenthal, commissioner of the newly formed Department of Bridges, designed the Queensboro Bridge with architects Henry Hornbostel and Leffert L. Buck (the designers of the Williamsburg Bridge).

The August 1907 collapse of the Quebec Bridge caused delays on the Queensboro as its soundness was evaluated. Then, in September, an uncompleted span collapsed during a violent windstorm. But the biggest threat to the bridge was labor disputes. Bridge ironworkers did one of the most dangerous jobs in America. High above the windy river, riveting gangs working with no safety helmets and maybe only a rope cord for a safety harness would toss red-hot rivets to each other. They were a rough group, often former sailors, surefooted and used to working high up in rigging. Following two lengthy strikes by ironworkers, in 1905 and 1906, work on the Queensboro Bridge resumed in April 1906 with nonunion workers. In March 1908 eight sticks of dynamite were reportedly found lashed to the western part of the island span. The International Association of Bridge and Structural Iron Workers was known to be conducting a "dynamiting campaign," and in October 1912 George E. Davis was arrested in Indianapolis and confessed to dynamiting eleven bridges. He said he had scouted the Queensboro Bridge in 1908, planning to use two hundred pounds of dynamite on it, but eventually refused the job for fear of killing innocent bystanders.

The bridge opened on March 30, 1909, with two hours of fireworks, and throngs of revelers in their Sunday best came to parade over its walkways. It had cost $20 million and the lives of fifty men. The marvelous vaulted Guastavino tile arches under the Manhattan approach would become a popular and crowded marketplace (page 81).

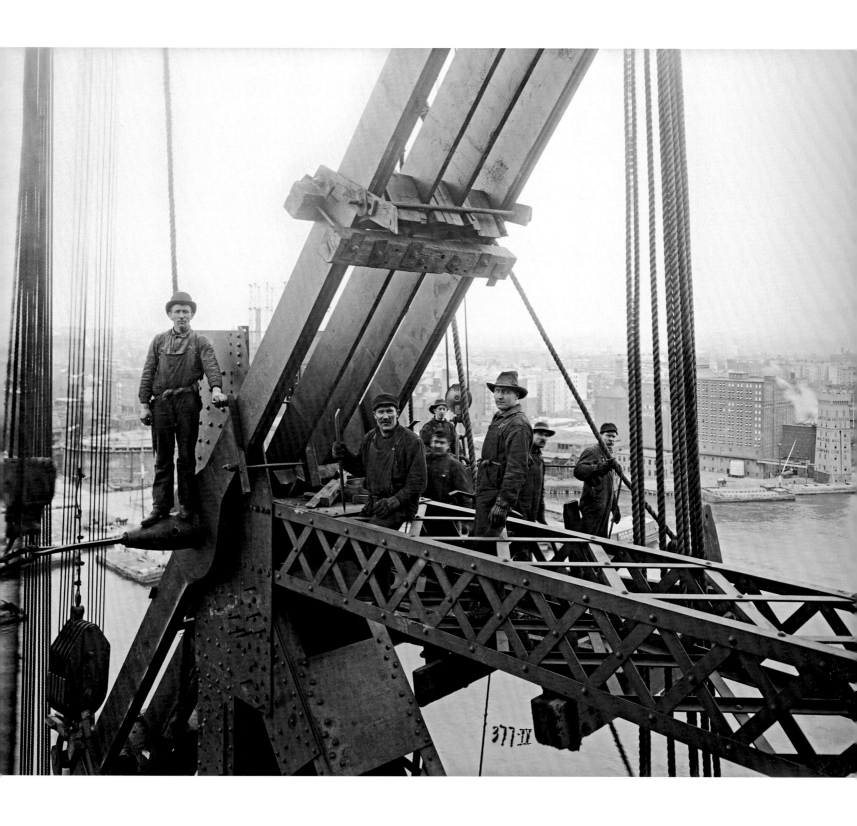

Queensboro Bridge, pier in place, upper
deck, northeast, May 2, 1907

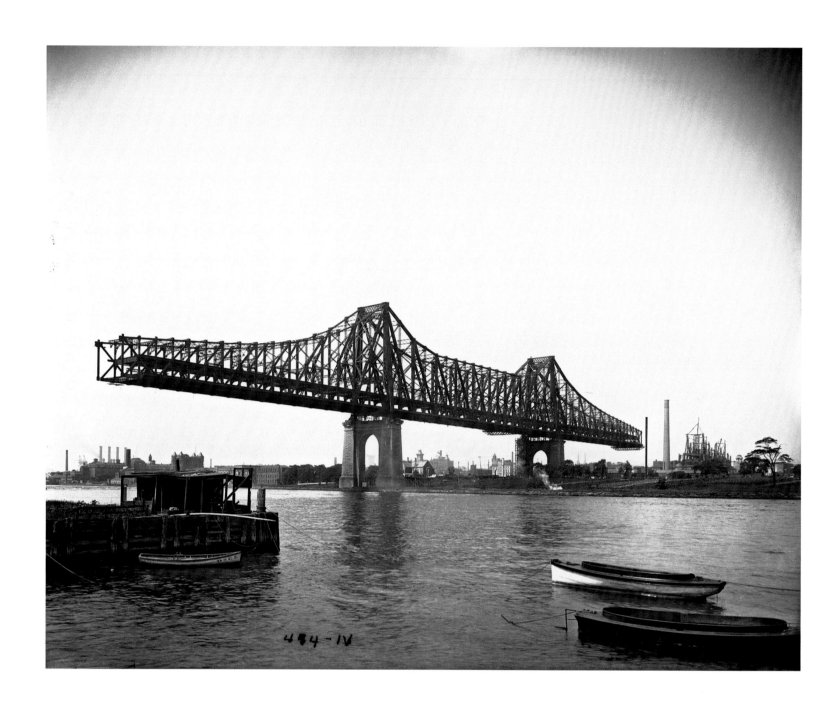

Queensboro Bridge, from Ravenswood shore,
August 8, 1907

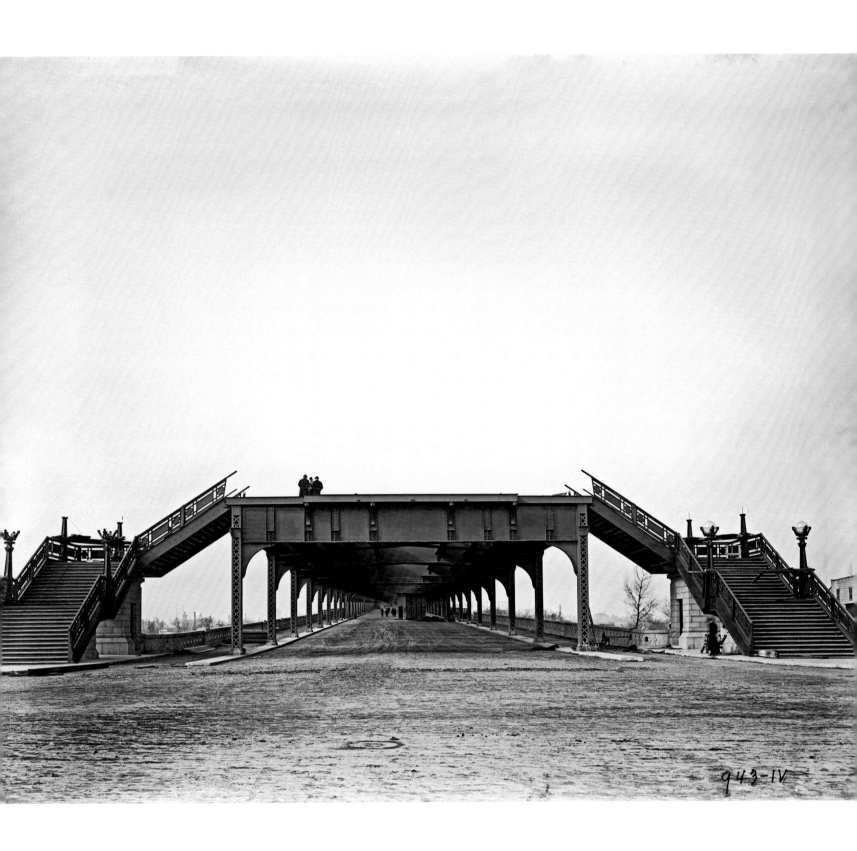

Queensboro Bridge, approach from Crescent
Avenue, Ravenswood, January 8, 1908

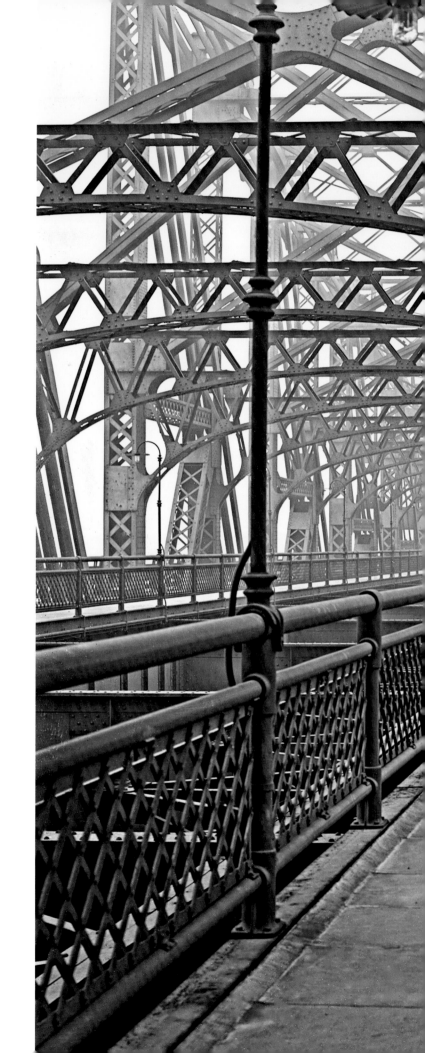

Queensboro Bridge, exposures made for
experiment, February 9, 1910

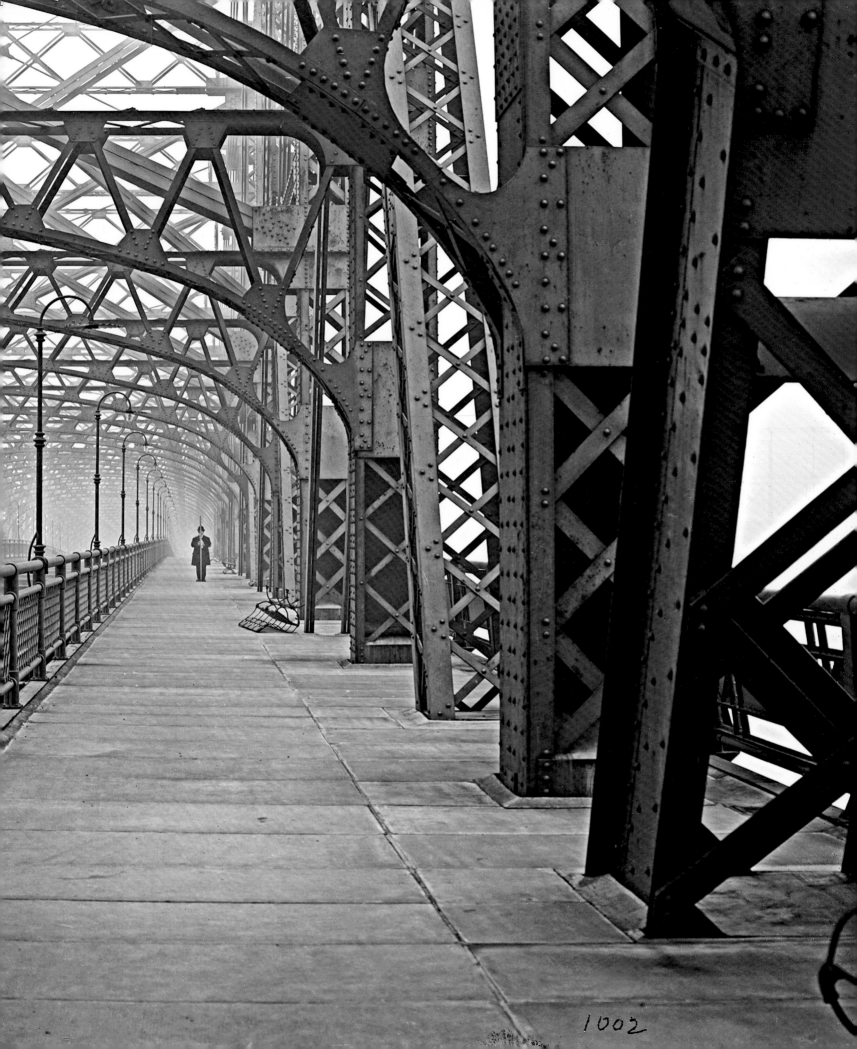

1002

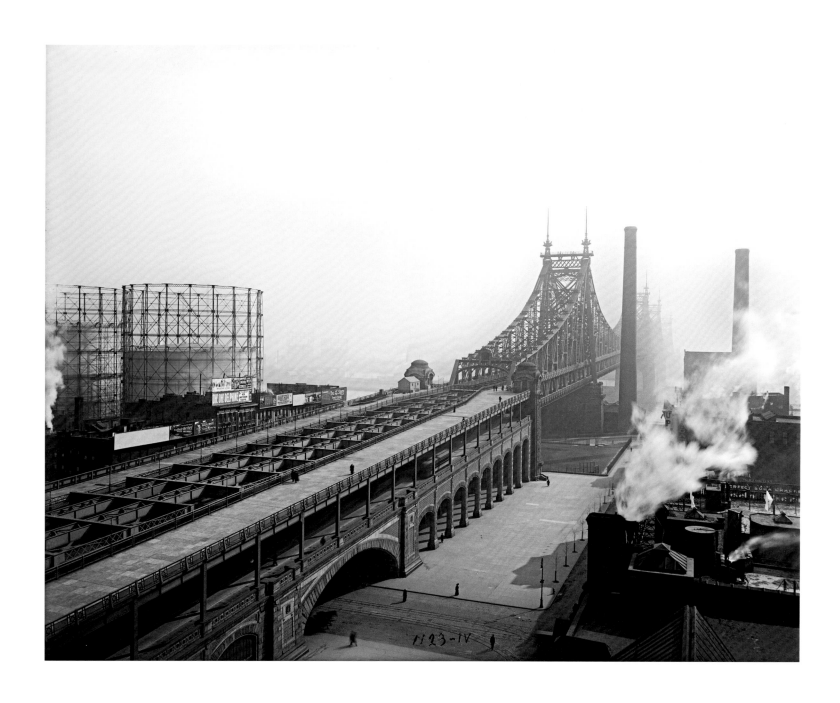

Queensboro Bridge from roof of Wallach's
Laundry, East 59th Street, looking east,
February 19, 1913

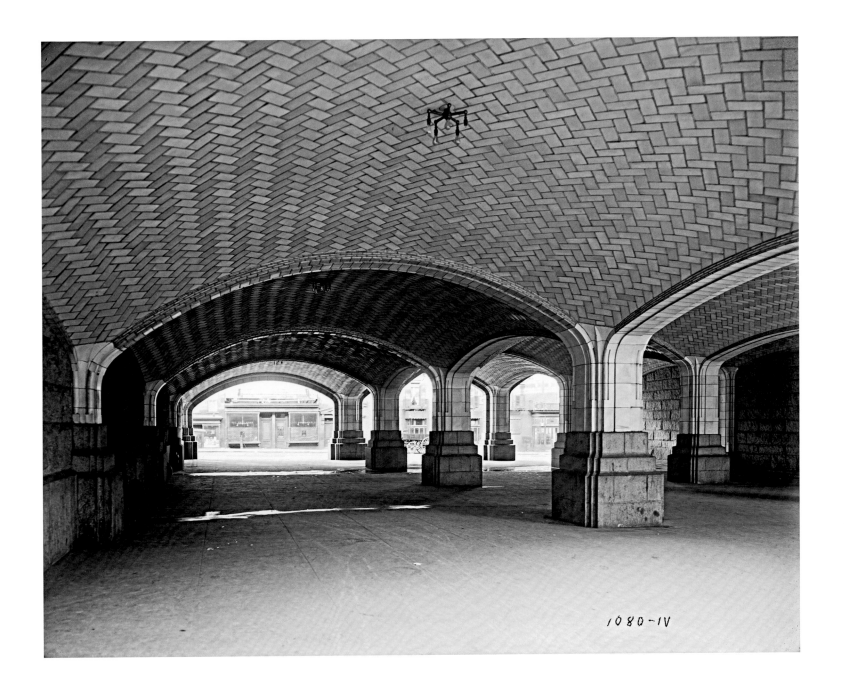

Queensboro Bridge, showing interior of arches
west of First Avenue, February 20, 1912

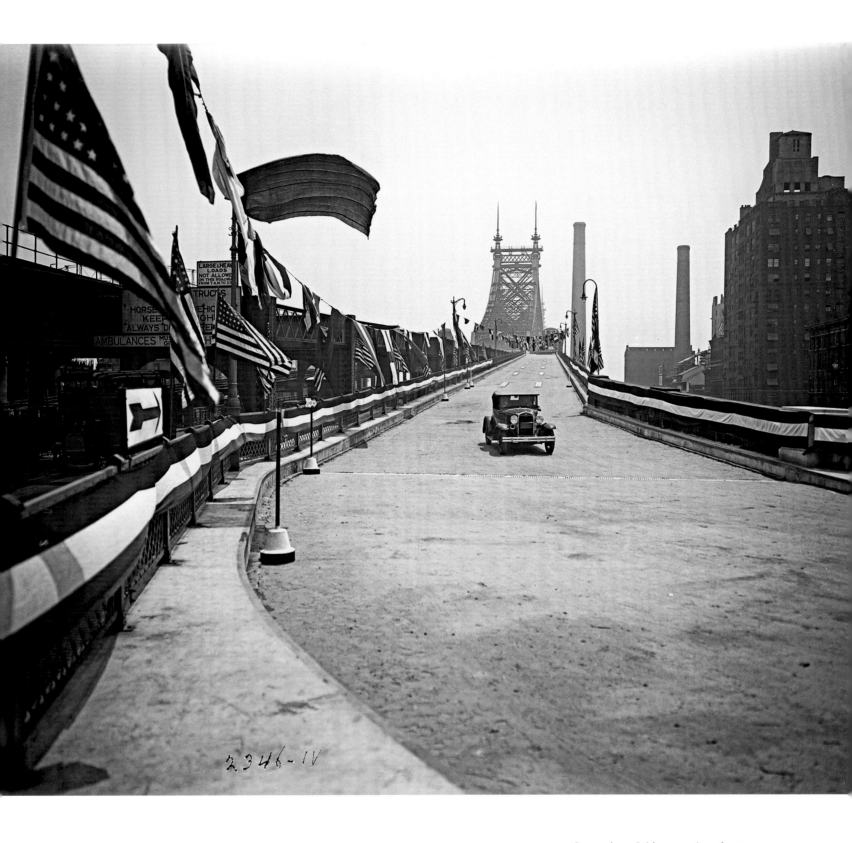

**Queensboro Bridge, opening of upper
roadway, Manhattan, June 25, 1931**

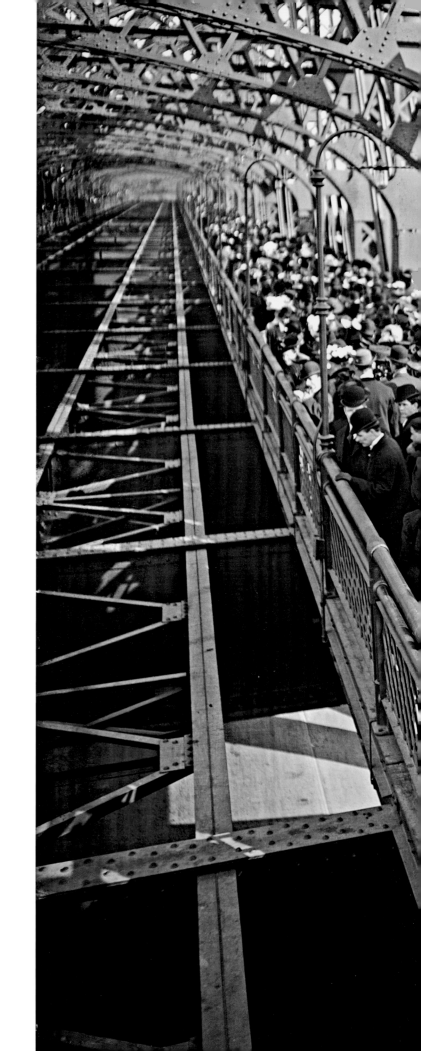

Queensboro Bridge, from roof of shanty
looking east, showing 3:50 PM congestion on
south foot walk, Manhattan side, April 11, 1909
[The bridge opened to traffic on March 30,
1909.]

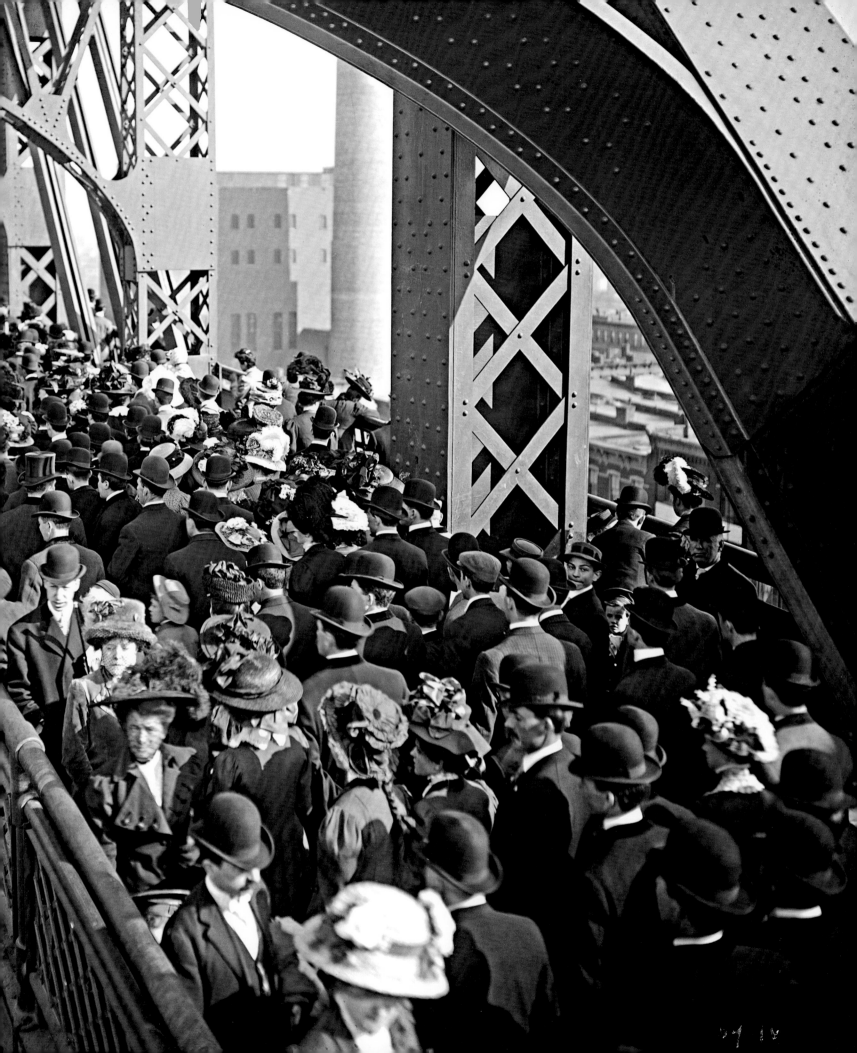

THE MUNICIPAL BUILDING

The Municipal Building was a major construction event of its time. After consolidation of the five boroughs in 1898, the city needed to bring together many government functions in a location close to City Hall. In 1907 a design competition was sponsored by the Department of Bridges, which intended to use part of the site for a new Brooklyn Bridge trolley terminal. The firm of McKim, Mead and White won the commission (their first skyscraper) with a design that was markedly similar to their winning entry for the new Grand Central Terminal uptown (below). The finished building spanned Chambers Street with a grand arch, allowing traffic and trolley cars to pass through it, and incorporated a subway station in its base (an urban design first). At 650,000 square feet, it was one of the largest government office buildings in the world. Joseph Stalin reportedly was so impressed that the main Moscow University building was based on it, which in turn influenced much of Soviet public architecture.

Built almost concurrently with the Woolworth Building across City Hall Park, the Municipal Building utilized many of the same construction techniques, including the use of metal caissons to sink concrete pilings down to the deep-seated bedrock.

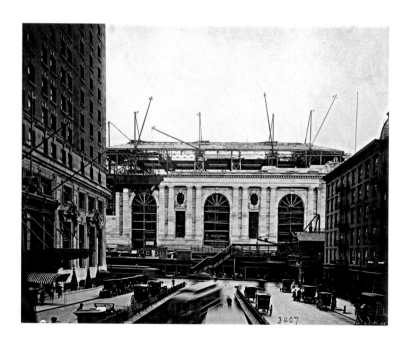

Showing derrick at Grand Central Depot,
April 18, 1912

Raising girders for Municipal Building, February 26, 1911 [The building in the background is the Hall of Records, which now houses the Municipal Archives.]

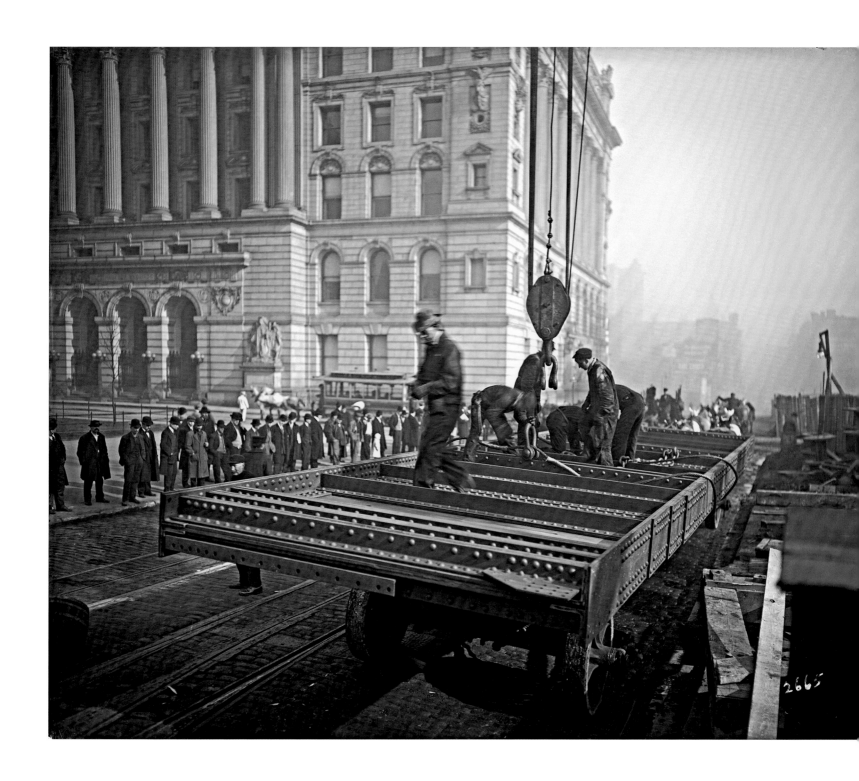

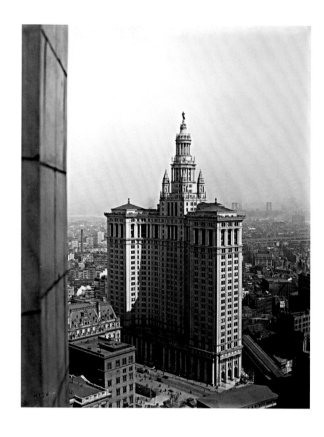

Municipal Building from 29th floor of Woolworth Building, September 18, 1914

De Salignac photographed every stage of the Municipal Building's construction, often from the top of the Woolworth Building's girders, and he also shot the newly completed Woolworth Building from the unfinished upper floors of the Municipal Building (page 6). In 1914 the Department of Bridges moved to the Municipal Building's eighteenth floor, and de Salignac would spend the rest of his career there.

Even though it was far shy of the 794-foot Woolworth Building, the Municipal Building at 559 feet was one of the tallest buildings in the city. It was topped off by Adolph Weinman's 20-foot-tall *Civic Fame*, the second largest statue in the city after the Statue of Liberty. (The crown she holds aloft is five-pointed, to symbolize the joining of the five boroughs.) Just visible on the top of the Municipal Building's tower in de Salignac's 1912 photo (opposite) is a silhouette of Weinman's statue. Stanford White had suffered an embarrassing gaffe with the oversized statue of Diana atop the original Madison Square Garden, and this silhouette may have been used to test the scale of *Civic Fame* before installing it.

OPPOSITE: Municipal Building showing front elevation from Pearl Street, January 11, 1912

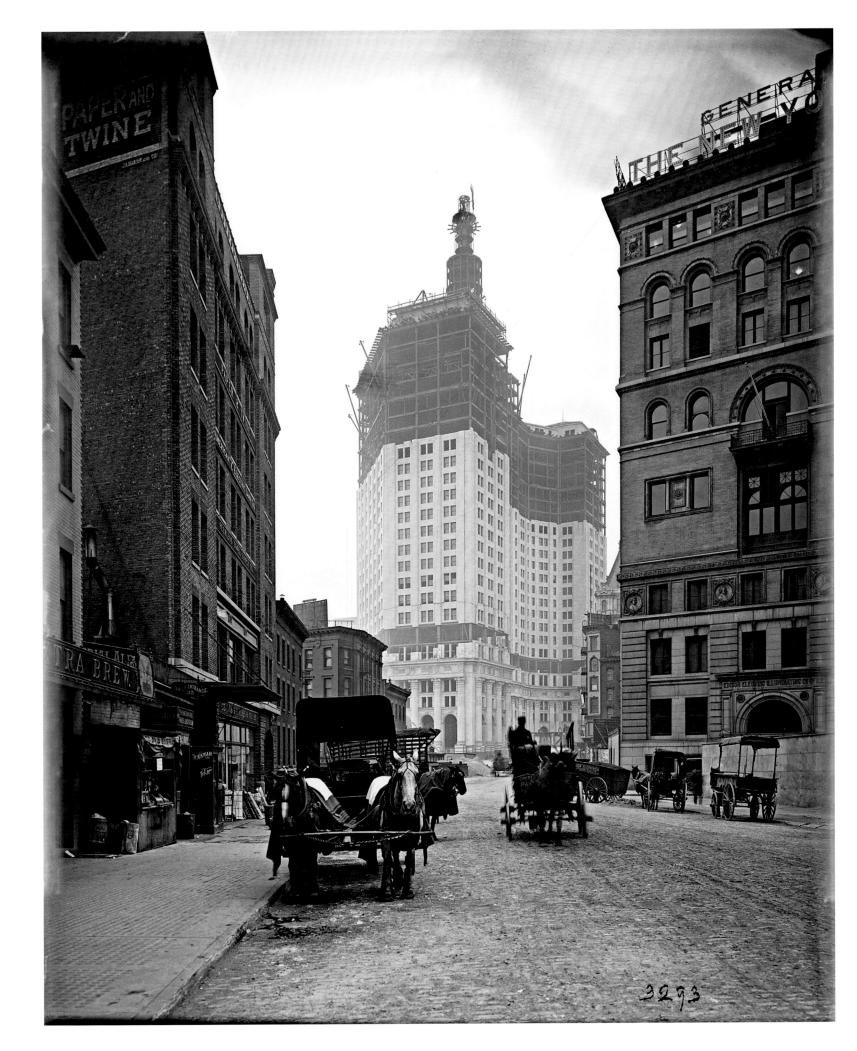

INSPECTING THE CITY

A well-maintained city needs to be well inspected. Throughout de Salignac's career, measuring is a recurring theme in photographs that record the volume of vehicular and pedestrian traffic, lengths of cracks in beams, dips in roadways, movement in bridges, and stress tests on building materials. One series of photos shows two men pushing the silhouette of a new subway car around the city's bridges — a very practical way of verifying that the new cars would have adequate clearance (page 95). A beautiful still life of a basket of pears is followed by the same "1 quart" basket empty except for wadded paper (page 92). Shot for the Department of Weights and Measures, this pair of pictures illustrates how merchants could cheat the unwary buyer.

New technological developments also required de Salignac's documentation. New types of cable cars, trackless trolleys, sanitation vehicles, police motorcycles, buses, armored payroll cars, and ferry boats were all advances in transportation that he recorded. A seemingly endless supply of gadgets and new equipment also passed before his lens, including high-powered washers, early spray-paint guns, powersaws, motors, gears, cables, snow shovels, bolts, levers, pumps, and so on.

Brooklyn Bridge, showing railing on north side of foot walk, looking west from the Manhattan end, where accident occurred, October 2, 1917

Williamsburg Bridge,
extensometer gauge, 20"
capacity, reading being taken at
northeast main lower leg, south
side, December 24, 1913

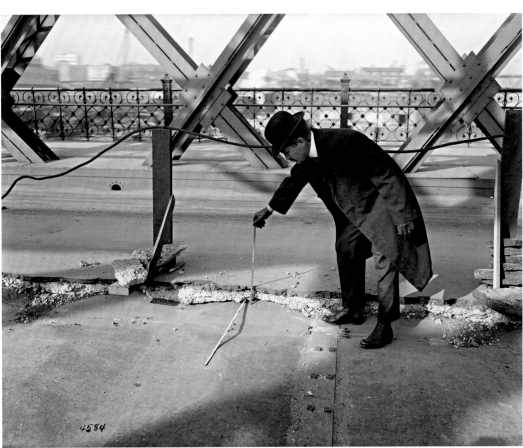

Willis Avenue Bridge, showing
asphalt roadway condition,
December 1, 1915

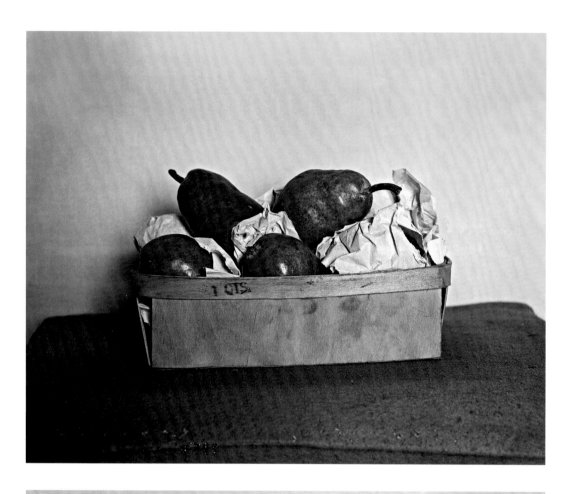

Department of Weights & Measures, view showing fruit basket — pears, October 3, 1919

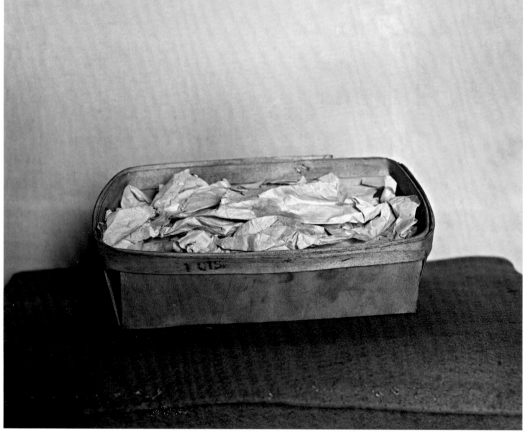

Department of Weights & Measures, view showing fruit basket — empty, October 3, 1919

OPPOSITE: Showing sample of rivets from rivet test, September 25, 1911

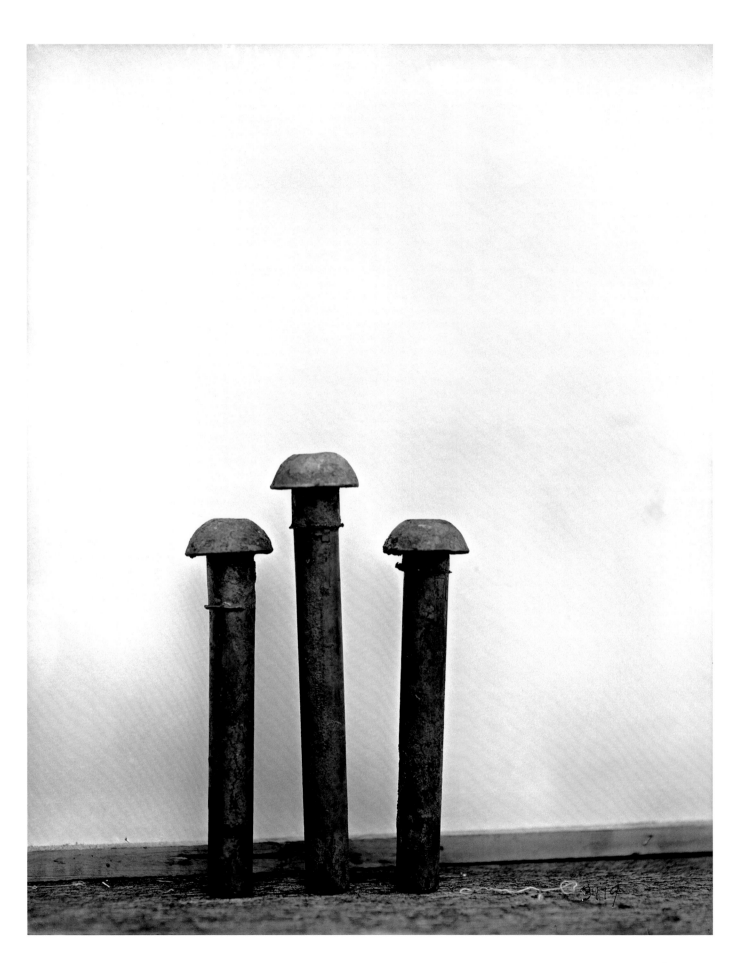

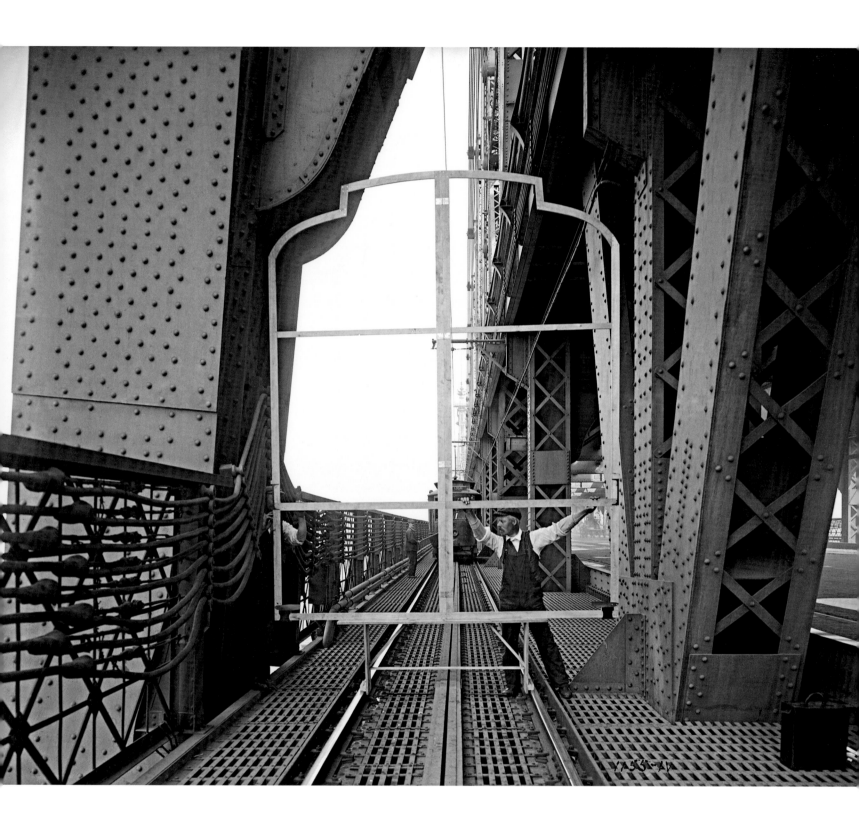

Queensboro Bridge, template of 10-foot car
on north outside track, template on present
track line and 1'11" above present grade,
May 22, 1914

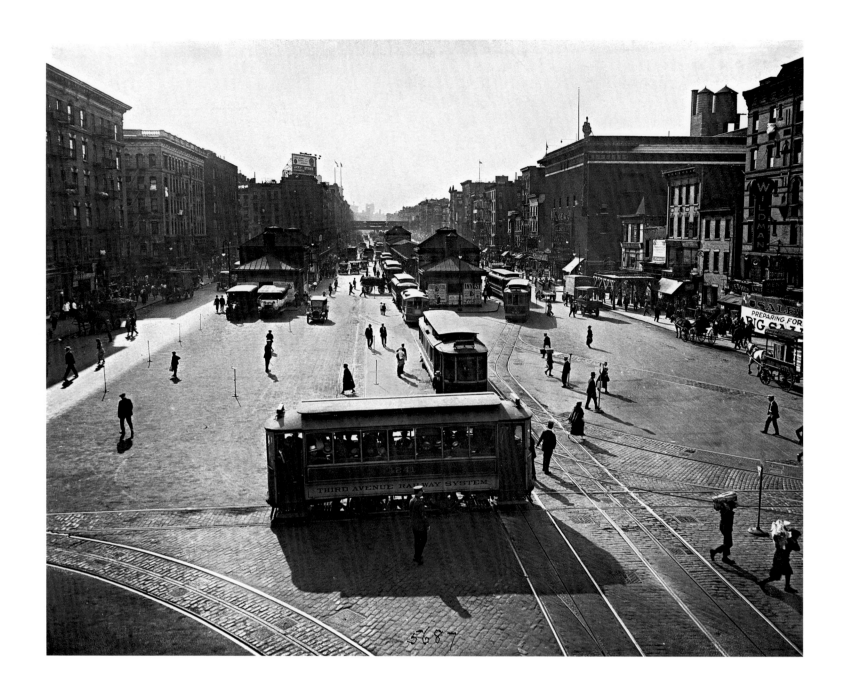

Williamsburg Bridge, view showing traffic congestion looking west along Delancey Street, 5:40 PM, June 30, 1919

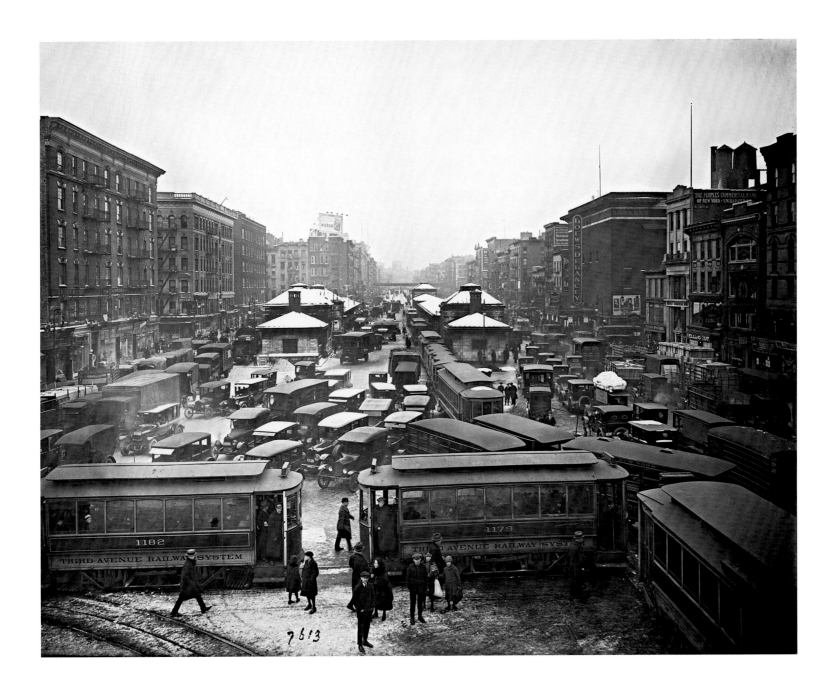

Williamsburg Bridge, view looking west from
esplanade, showing congested traffic,
Manhattan, January 29, 1923

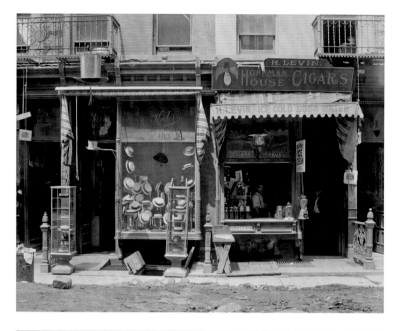

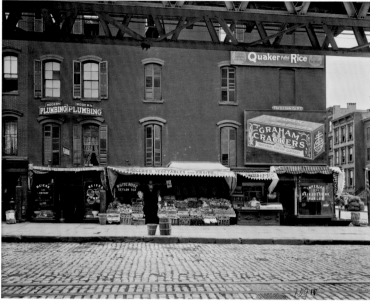

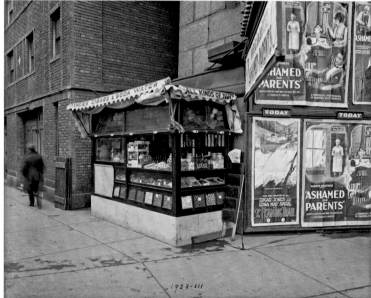

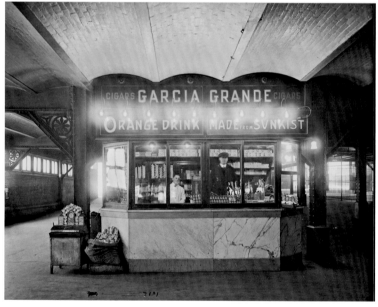

103 Clinton Street, stoop lines, July 27, 1908

1114 Second Avenue, between 58th and 59th
Streets, June 16, 1908

Manhattan Bridge, view showing soda and
candy stand at East Broadway and Henry
Street, June 20, 1922

Brooklyn Bridge, soda stand, ground level,
March 9, 1922

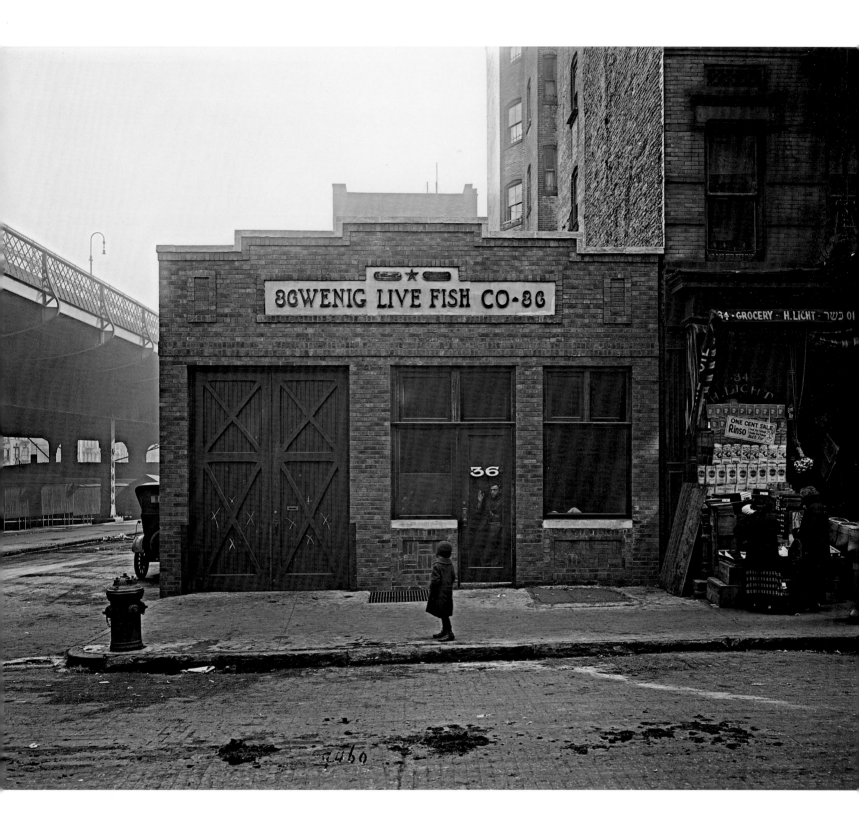

Williamsburg Bridge, view showing fish
market, south clearance [Delancey] and
[36] Pitt Street, February 20, 1925

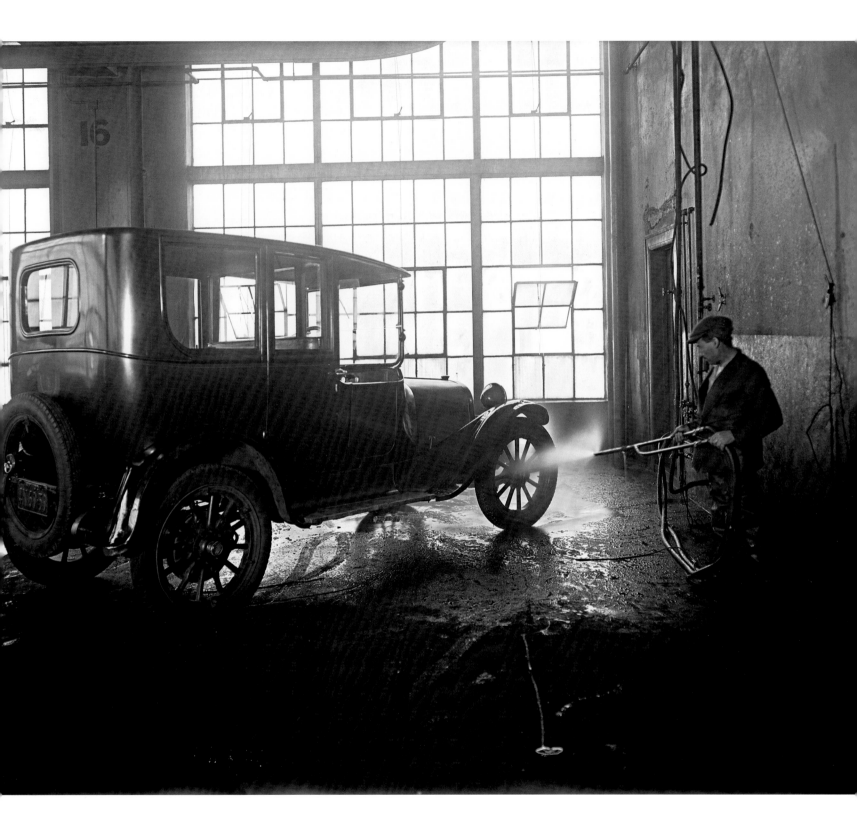

**Central Motor Repair Shop, showing
machinery for cleaning, February 14, 1930**

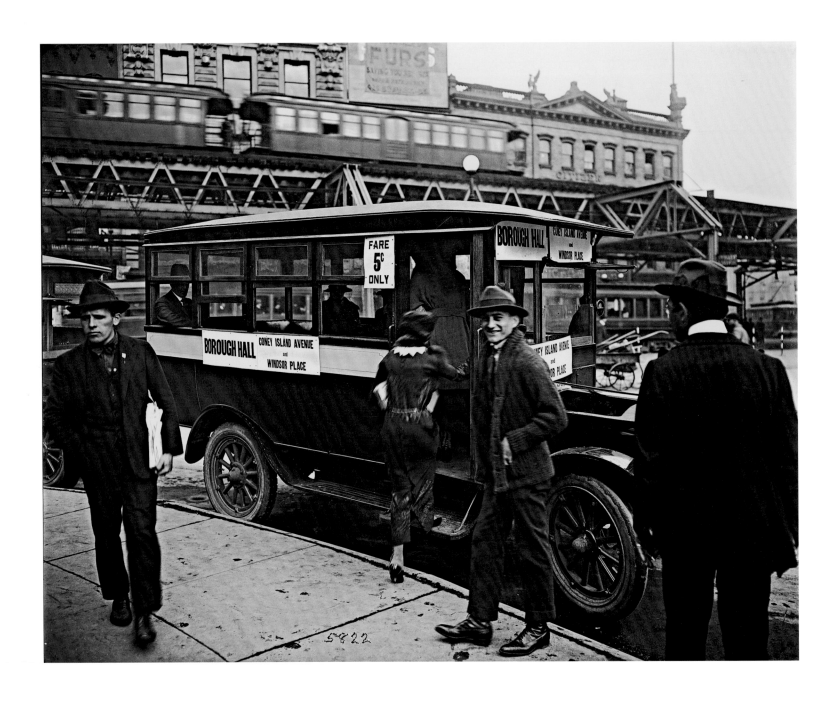

Stage Line, Manhattan Bridge, view at
Borough Hall, Brooklyn, October 31, 1919

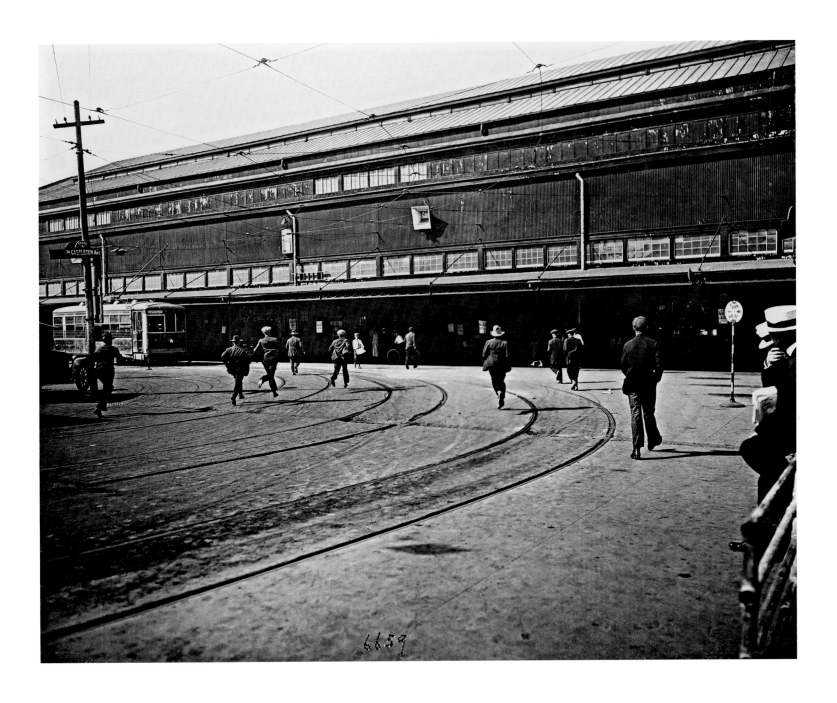

Staten Island Ferry, St. George, view
showing crowd, June 14, 1921

Staten Island Municipal Ferry Terminal,
crowd on board ferry President Roosevelt,
June 8, 1924

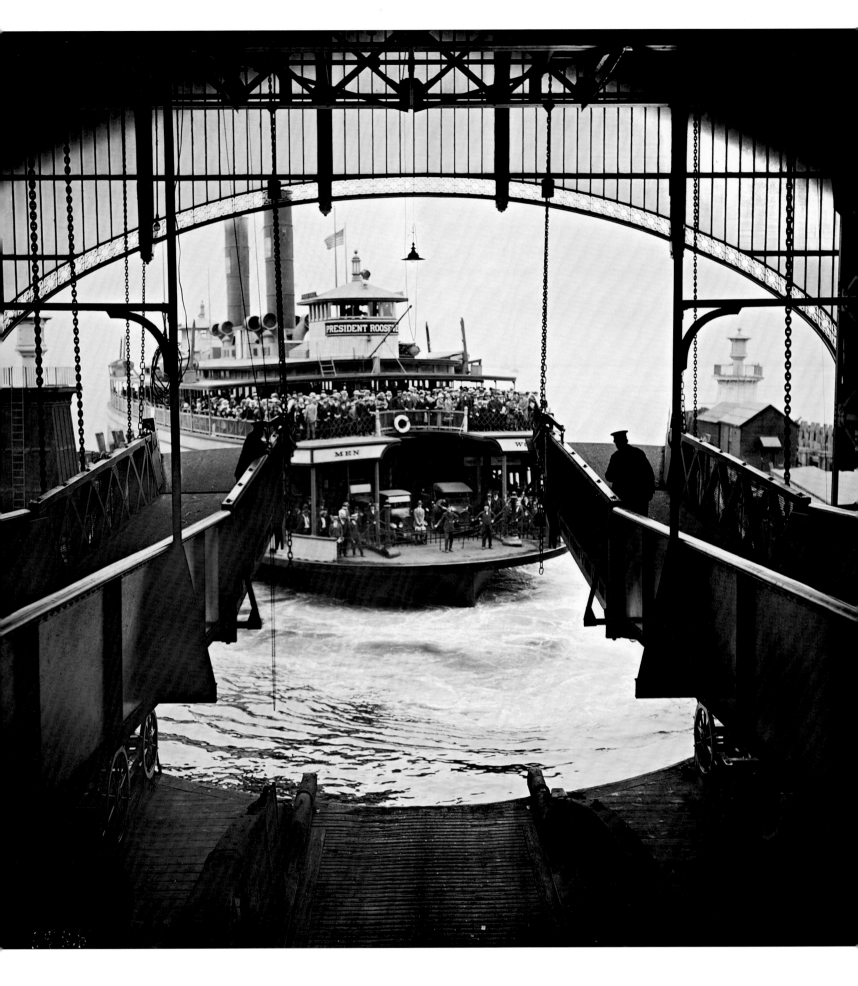

ACCIDENTS

On June 25, 1923, a Bay Ridge–bound elevated train of two cars jumped the tracks at the junction of Flatbush and Atlantic Avenues, plunging into the street below (opposite). Seconds later, the steel undercarriage of one of the cars toppled over and smashed through one of the wooden cars, which had been in service since 1898. Seven people were killed instantly, and seventy wounded were taken to local hospitals. The Brooklyn-Manhattan Transit Corporation called it "an act of God," but Mayor James J. Hylan, a former railway motorman himself, demanded a full investigation. City inspectors later found that 50 percent of the ties and guardrails in the section were rotten and in need of replacement.

An important part of de Salignac's job seems to have been photographing accidents that occurred on or under New York City bridges or that involved city-operated bus lines. These were documents made for the city's Corporation Counsel to use in possible legal cases or to show needed repairs to damaged property. Often de Salignac arrived at the scene within minutes of the incident, before passengers had even been evacuated.

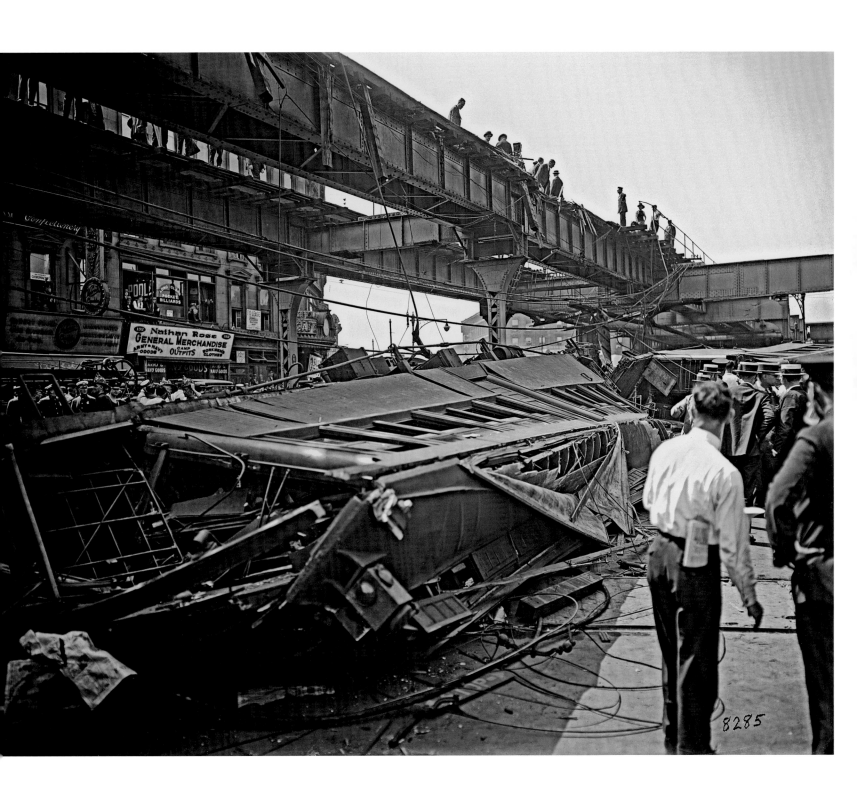

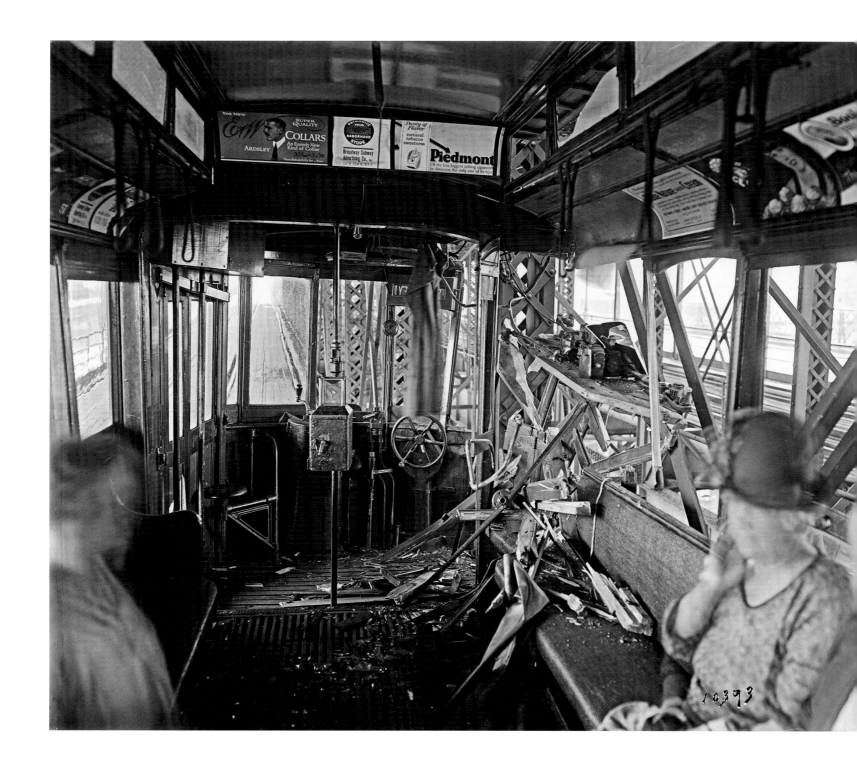

Williamsburg Bridge, showing accident,
interior of trolley car, August 16, 1926

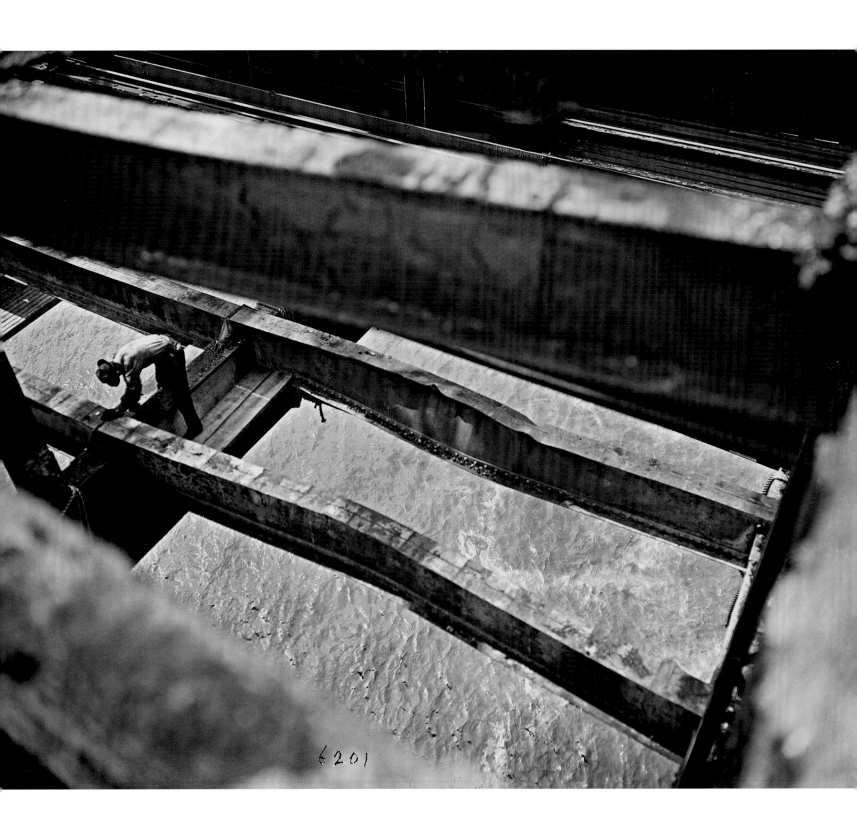

Williamsburg Bridge, showing fire damage
from point 52, July 31, 1920

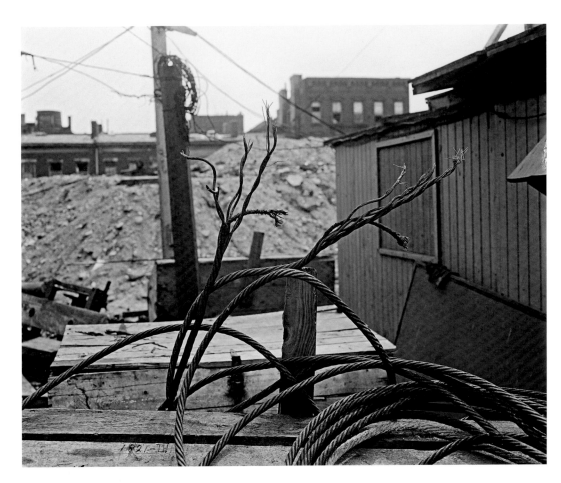

Manhattan Bridge, view
showing cable ends [from
fallen derrick], July 20, 1917

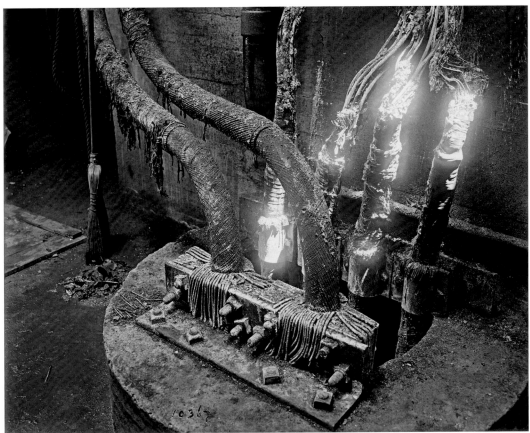

North Channel, Howard Beach,
showing electrical works burnt
out by lightning, July 19, 1926

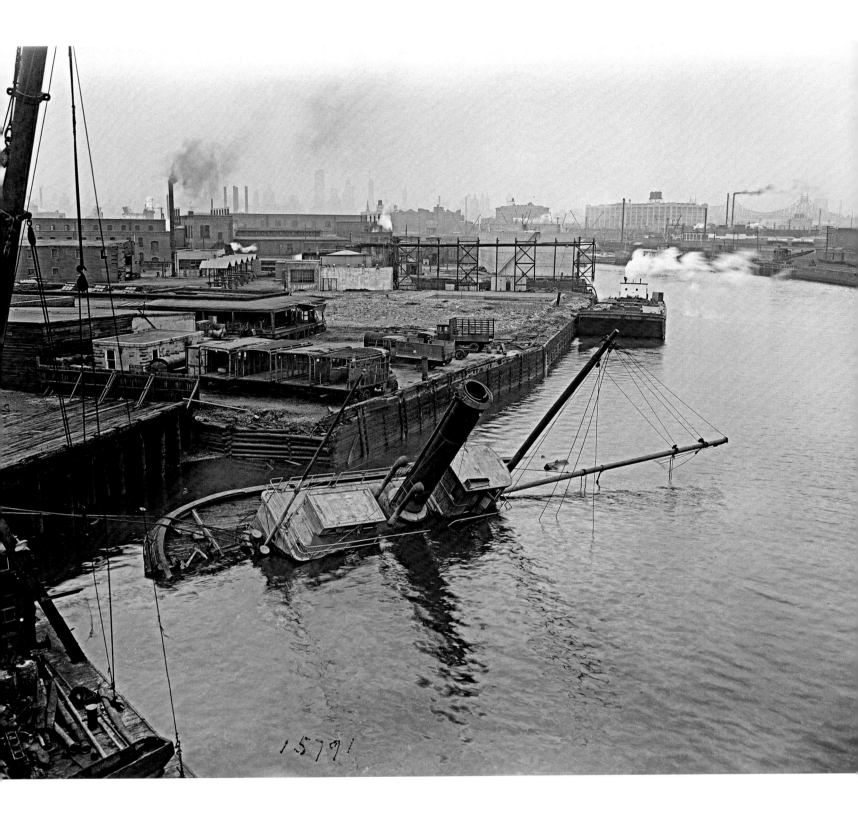

15791

Greenpoint Avenue Bridge, showing barge
sunk, March 22, 1933

Manhattan Bridge, showing signal tower
for traffic, January 15, 1924

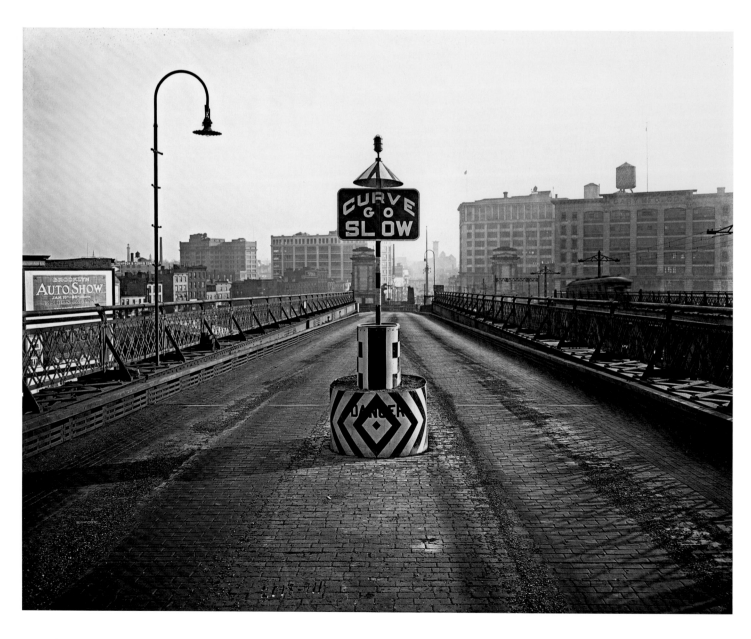

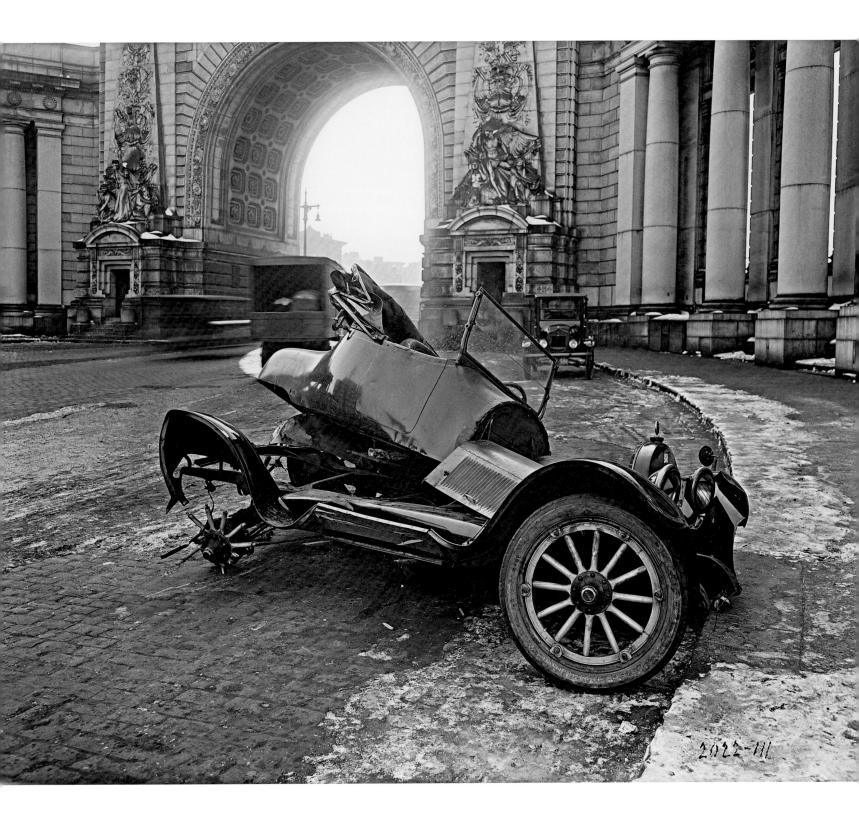

Manhattan Bridge, view showing auto
damaged by accident, February 23, 1924

THE DEPRESSION

As a major center of power and money, New York was the city largely responsible for putting the roar in the Roaring Twenties. It was also where the crash of 1929 first reverberated.

The 1930s had a bleak beginning in New York. President Herbert Hoover refused to create social welfare programs, fearing they would weaken the country's moral fiber. Instead he urged local municipalities to provide relief. Creating social programs that would later help shape the federal New Deal, New York put the able-bodied to work on bridges and other construction projects, and massive relief efforts were rolled out in 1930. Mayor Jimmy Walker (usually viewed as just the Jazz Age good-times mayor) started an ambitious welfare program, sheltering and feeding thousands. In October of 1930 he formed the Mayor's Official Committee for the Relief of the Unemployed and Needy. Calling on all his commissioners, he said, "The time is quite ripe when the entire resources of the City should be mobilized. . . . The first cold spell that falls on this city is going to find a terrible condition. I want to be prepared for it."

Recognizing that the needy do not necessarily ask for help, policemen on the beat went door-to-door, finding 78,000 households without income. City employees, whose jobs were for the most part secure, were asked to give 1 percent of their salary. Almost $1.5 million was raised in this manner during the first winter of the Depression, and the same the following year. The cooperation of the city agencies was so thorough and volunteerism so widespread that they could boast of spending only one-half cent on overhead for every dollar given away. That first winter they distributed 36.5 million pounds of food and 9,000 tons of coal, clothed 55,900 individuals, and gave out $187,000 for heat, light, and rent. But it was not enough — in 1931 there were ninety-five reported deaths from starvation in New York City.

By 1932 the Department of Plant and Structures had stopped work on the Triborough Bridge (finally completed in 1936), and the great era of city growth ground to a halt. De Salignac now photographed the job programs, breadlines, clothing distribution centers, and shelters (his photographs were used to illustrate the published report of the Mayor's Official Committee). In a rare instance of obviously personal work, he took a portrait of one hollow-cheeked and lost soul on the Staten Island Ferry (opposite).

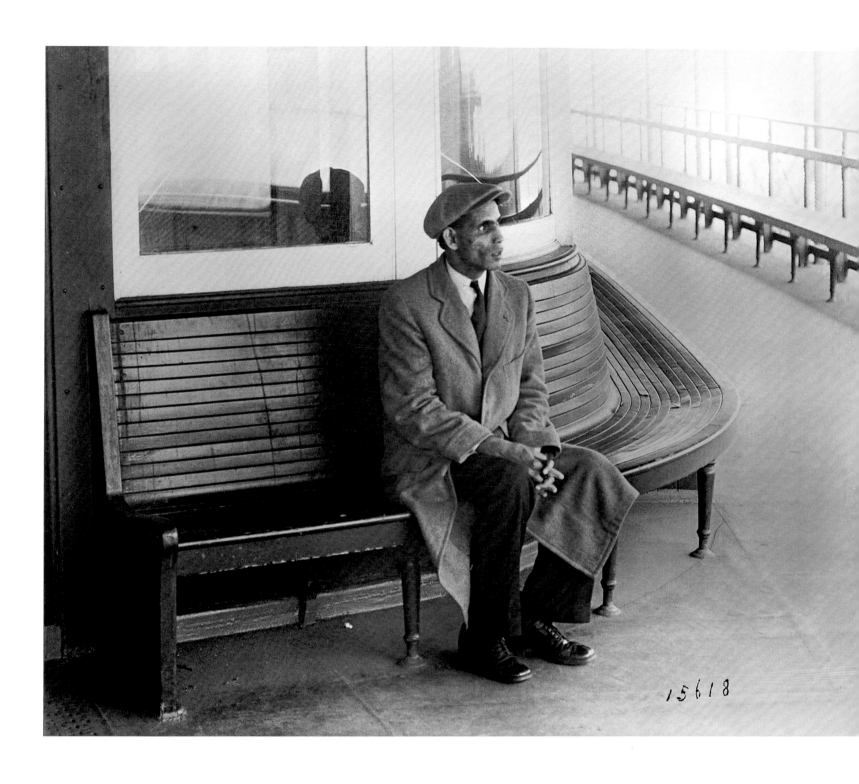

Municipal Ferry, Ferryboat Roosevelt,
"Individual," November 18, 1932

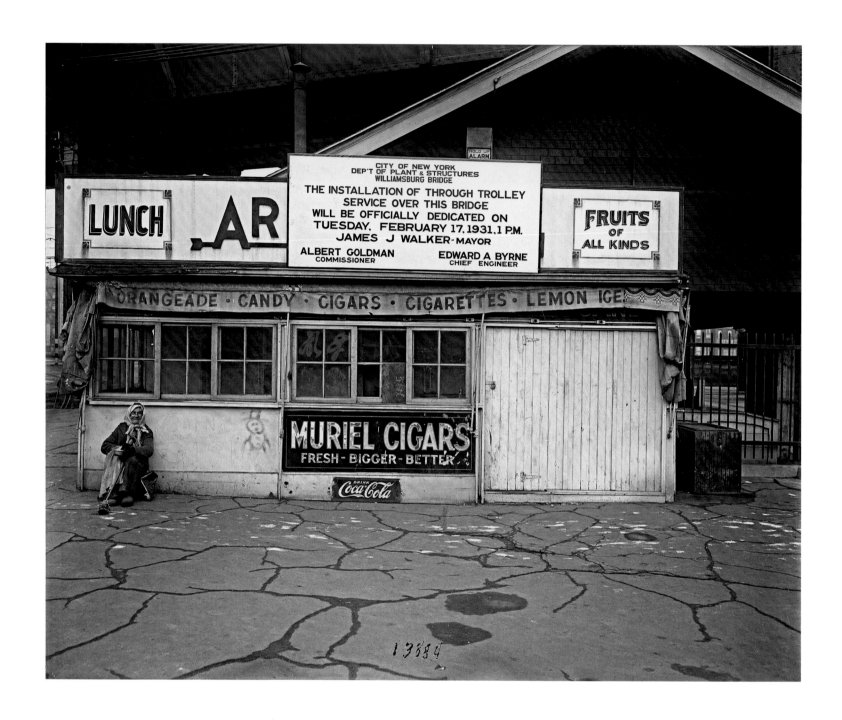

Williamsburg Bridge, Roebling Street,
Brooklyn Plaza, January 29, 1931

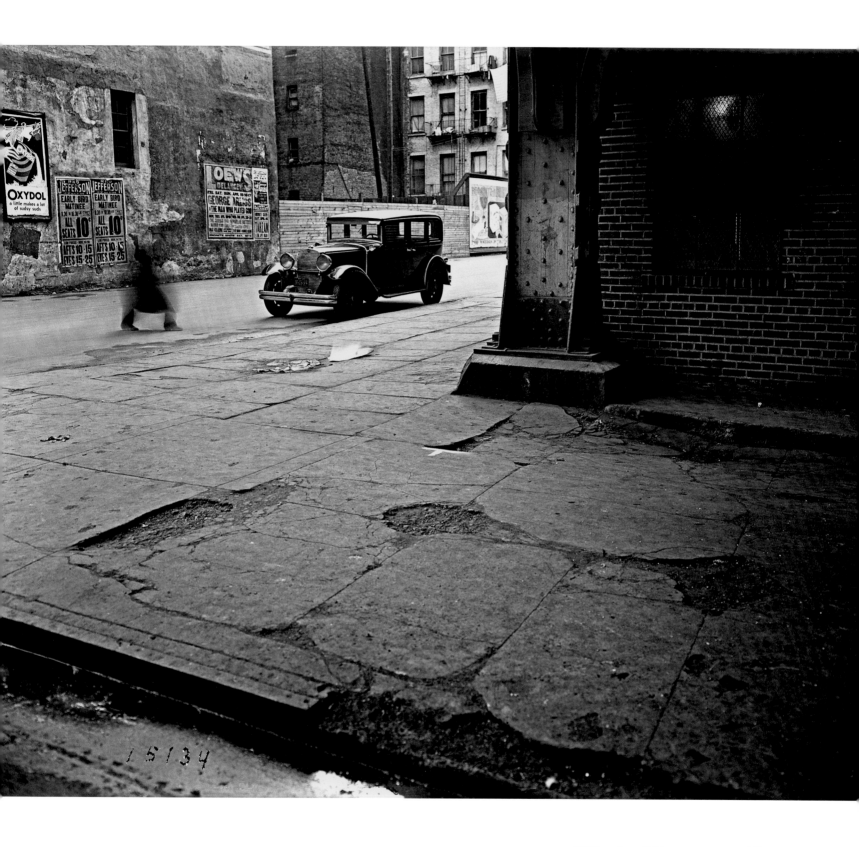

Williamsburg Bridge, west corner of Pitt Street — south clearance, April 13, 1932

**Municipal Lodging House, Department
of Public Welfare, East 25th Street,
November 22, 1930**

IT MAKES US ALL FEEL DEFINITELY AND IRREVOCABLY THAT NEW YORK CITY STANDS
OUT ALL ALONE, THAT THERE IS ONLY ONE NEW YORK AND THAT WHEN NEW YORK
CALLS TO A NEW YORKER THERE CAN BE ONLY ONE REPLY.

— Annual report of the Mayor's Official Committee for the Relief of the
Unemployed and Needy: July 1, 1931, to June 30, 1932 (Fiscal Year 1932)

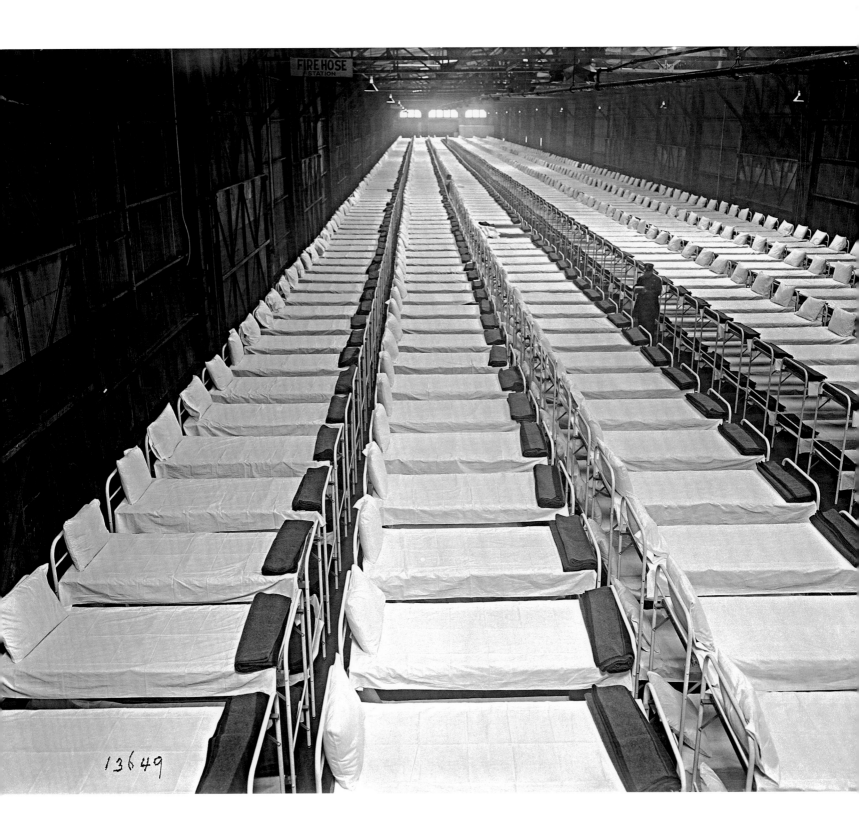

**Municipal Lodging House, Department
of Public Welfare, East 25th Street,
November 22, 1930**

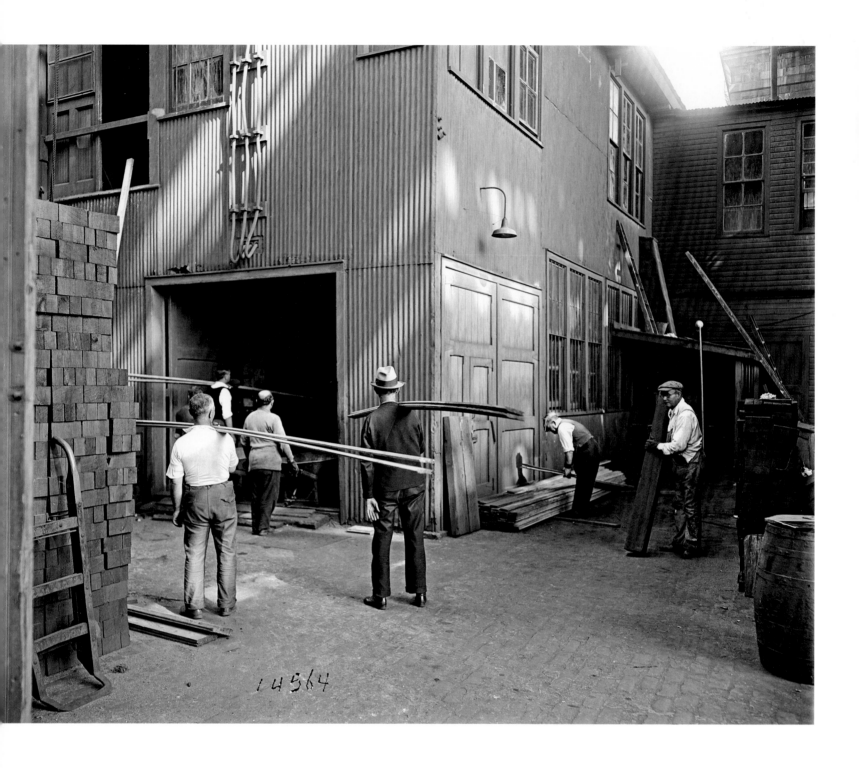

Williamsburg Bridge, showing unemployed,
September 8, 1931

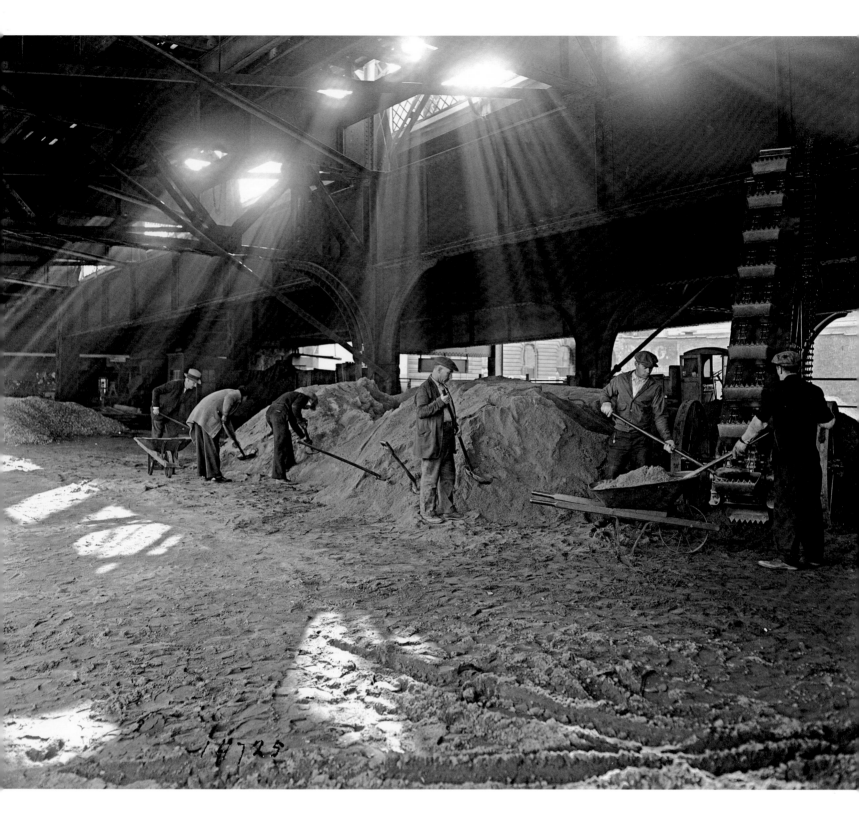

**Williamsburg Bridge, showing unemployed,
November 4, 1931**

WORKERS

One of the most intriguing aspects of de Salignac's oeuvre is his portraits — some group, some solo; some caught on the fly, others seemingly posed with care. They are comparatively few in number, yet tantalizing because they are so exceptionally strong. Most are photographs of city workers engaged in (or just pausing from) their daily tasks, whether digging, welding, chiseling stone, filing paperwork, or giving radio broadcasts. There is often an ease to his sitters that suggests de Salignac's rapport with them. He frequently catches them in unguarded moments, often in the distinctive settings of their work sites and with the tools that epitomize their labor. Some, like the portrait of the worker in the subway cut (page 141), transcend time and place to become iconic American types. This was the great era of industrialized labor as well as New York's coming of age, and de Salignac would have known that the city's transformation would not have been possible without the sweat of its vast and varied workforce.

Williamsburg Bridge Shop, in yard showing tree guard, November 29, 1912

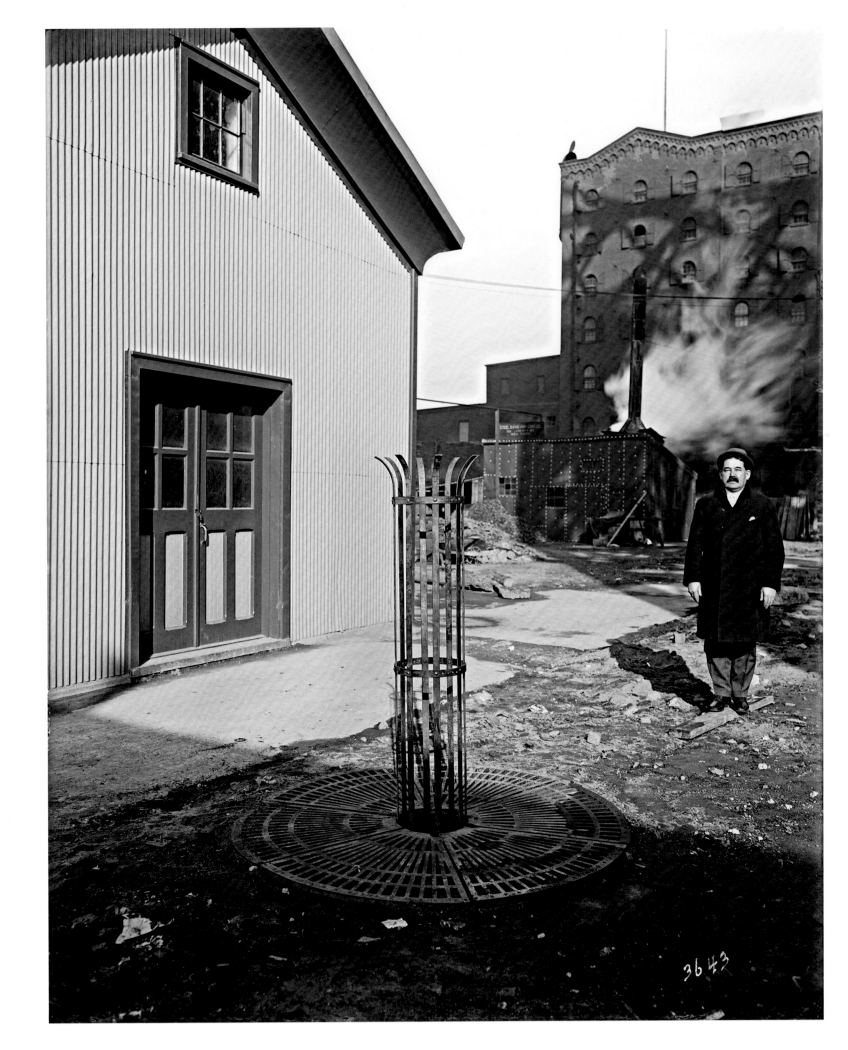

3643

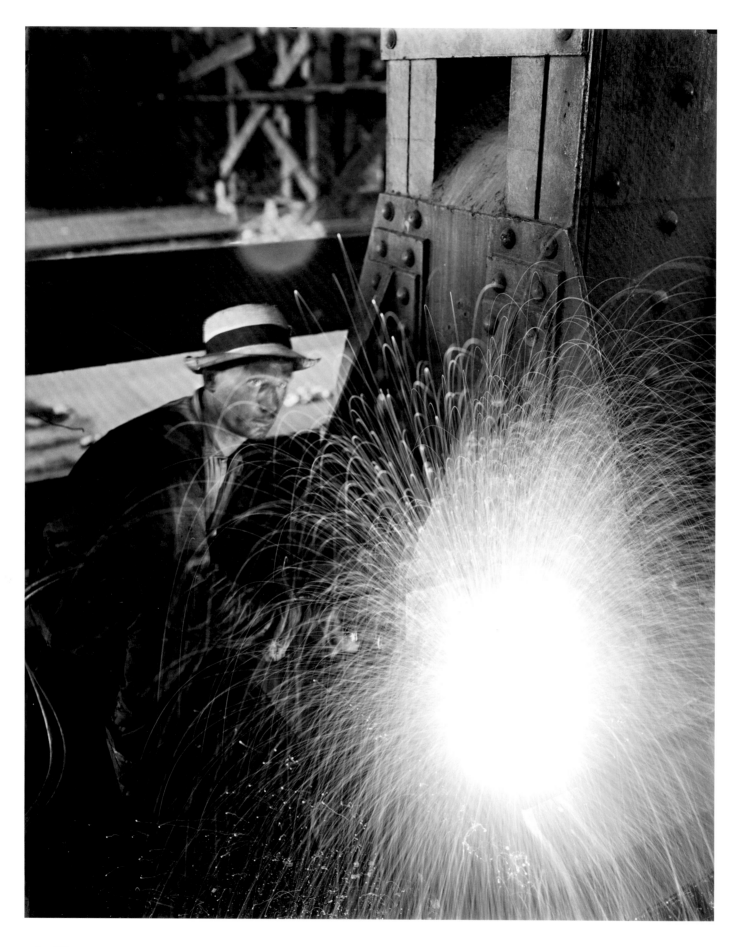

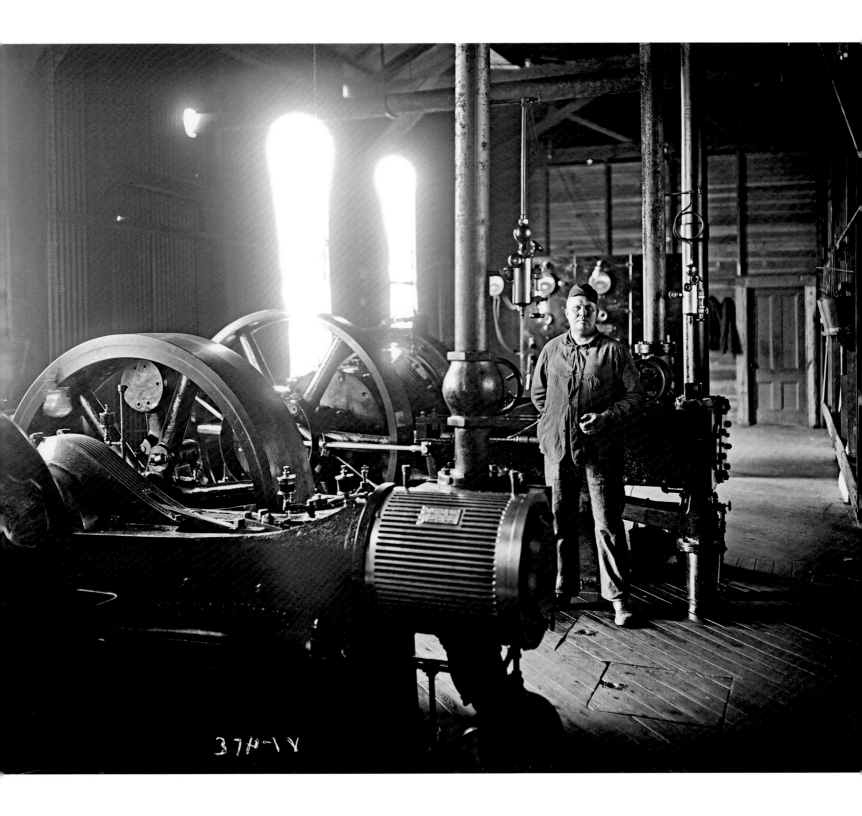

OPPOSITE: Williamsburg Bridge, cutting steel
plate, September 10, 1915

Queensboro Bridge, motor room, Penn Steel
Plant, Blackwell's Island, April 22, 1907

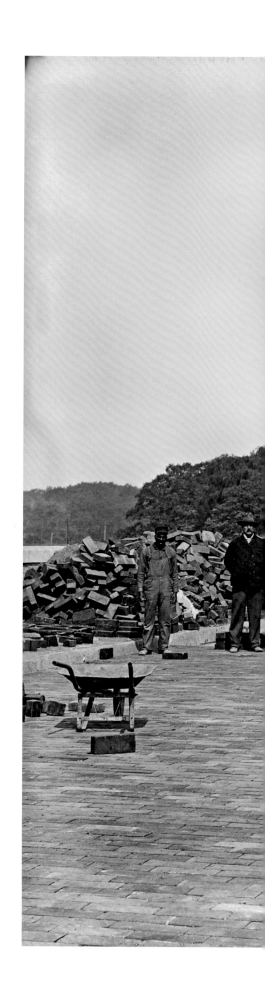

Pelham Bay Bridge, laying concrete blocks,
October 5, 1908

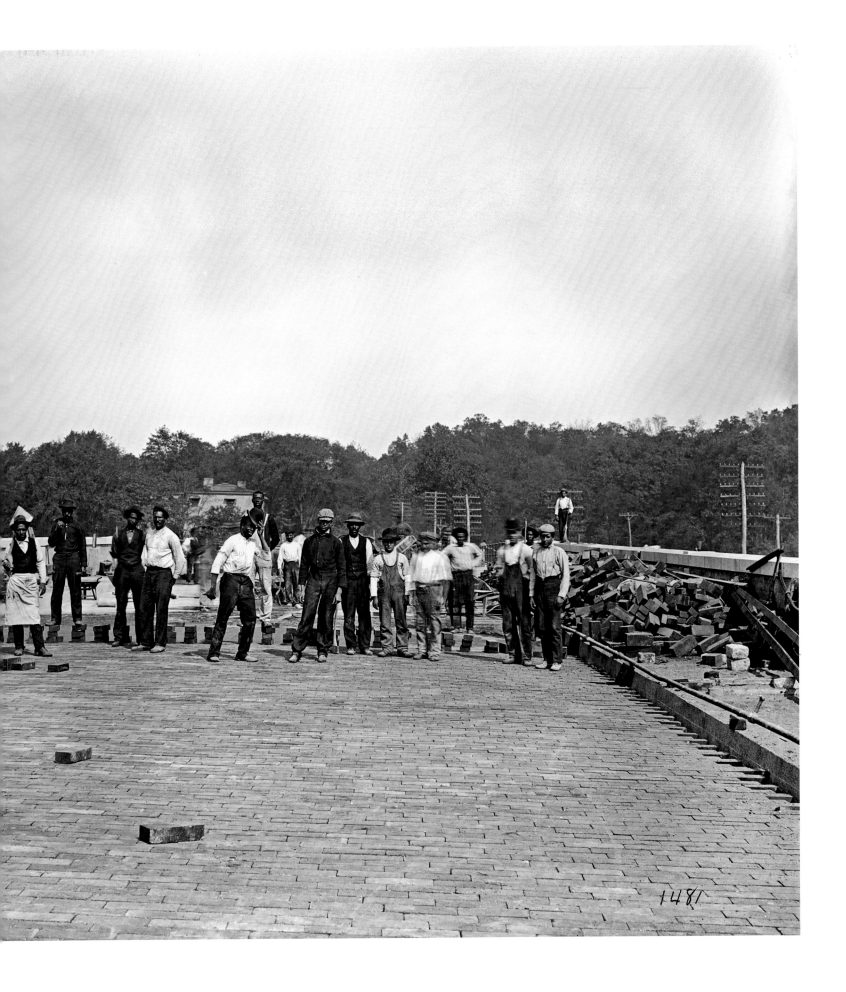

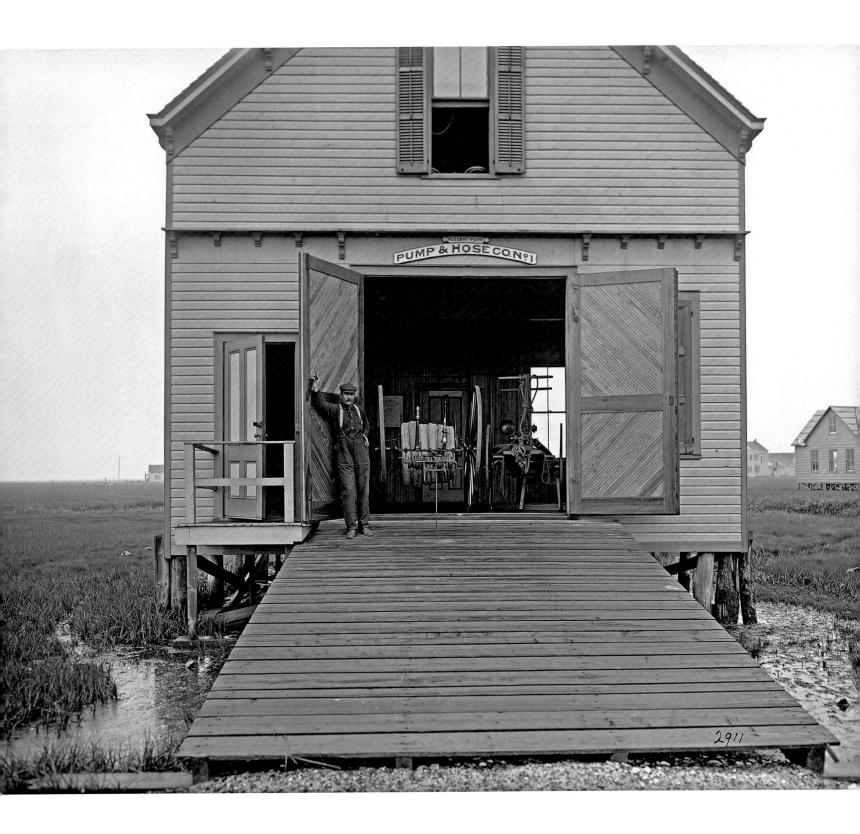

**Pump and Hose Company, Jamaica, Queens,
June 26, 1911**

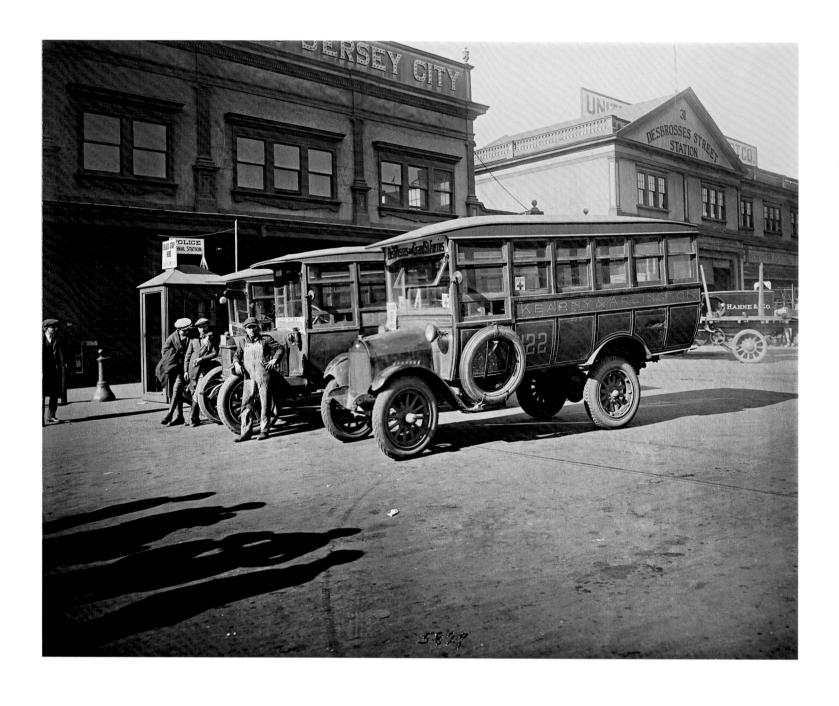

**Stage Line, Desbrosses Street Ferry, general
view of stages waiting, November 6, 1919**

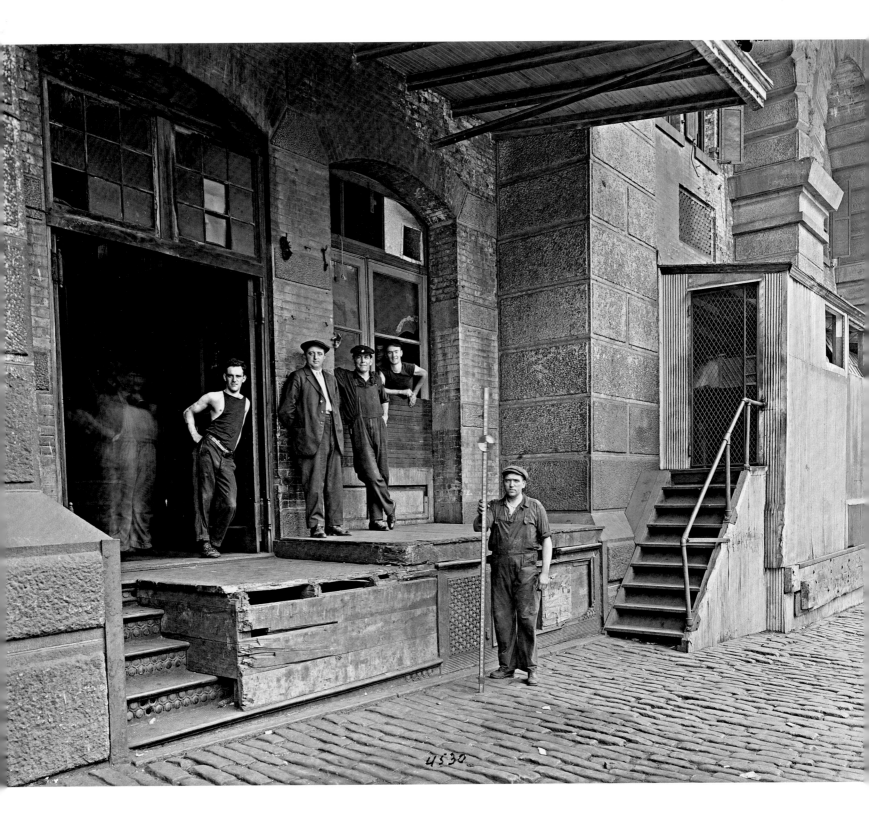

Brooklyn Bridge, showing front of 14-15 Rose
Street, September 17, 1915

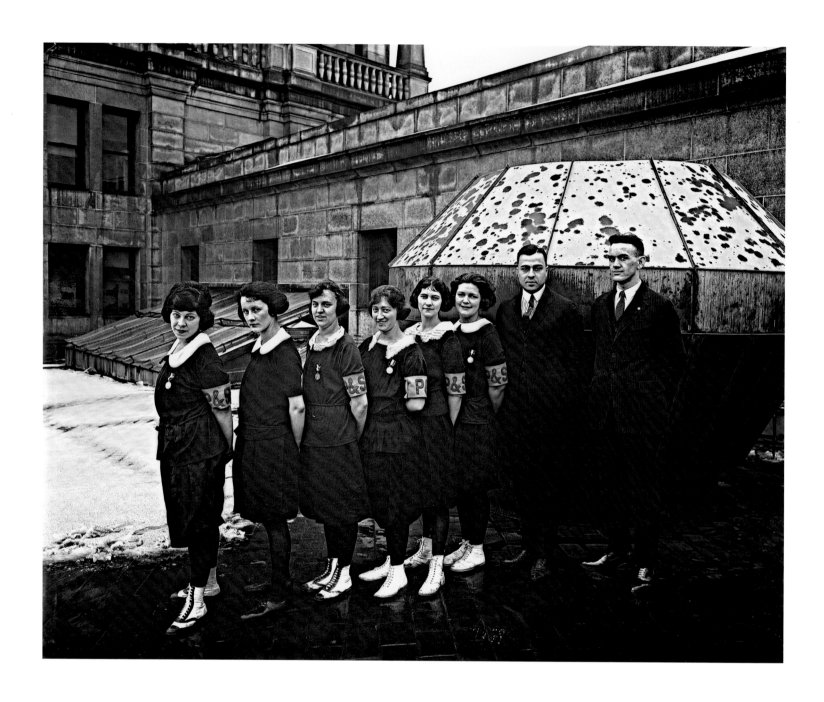

Basketball team, Municipal Building,
taken on the roof, March 2, 1922

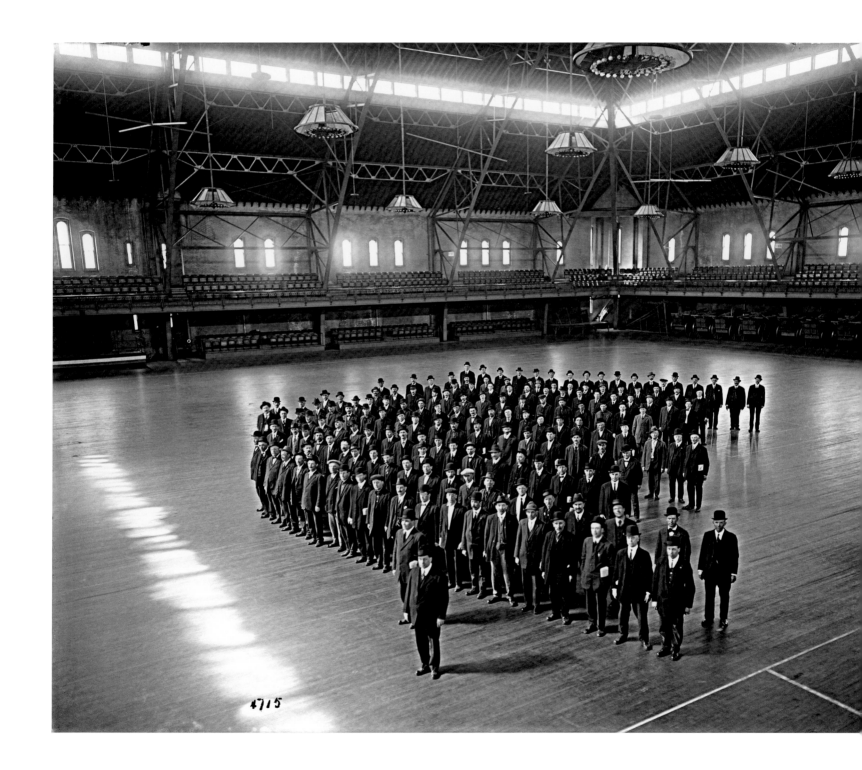

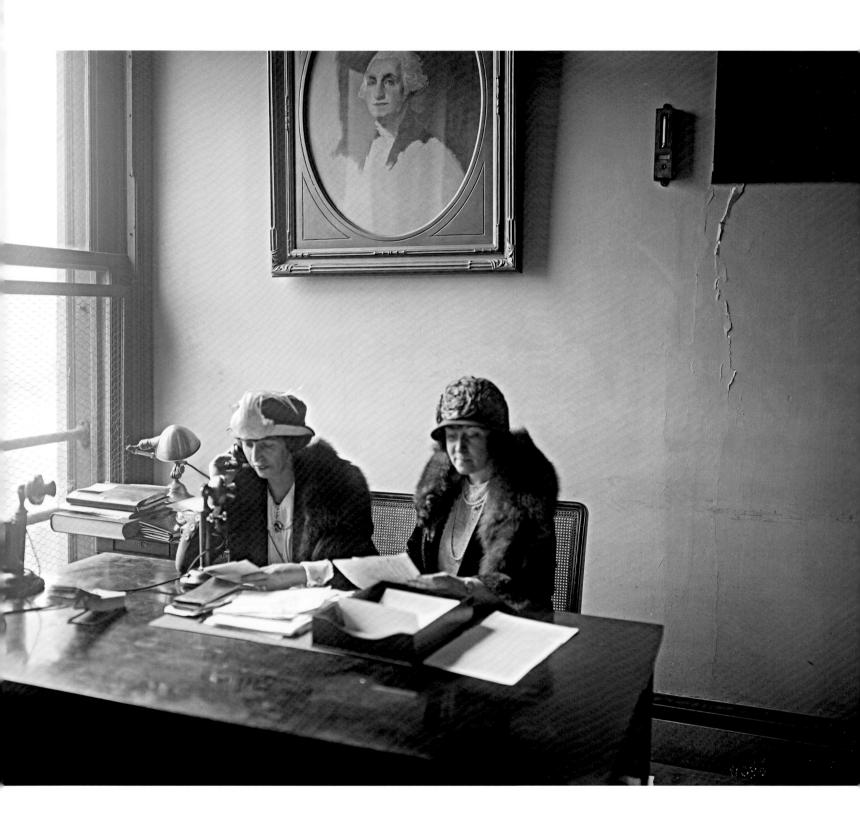

Room 2234, Municipal Building, two ladies,
Mayor's Committee, April 13, 1923

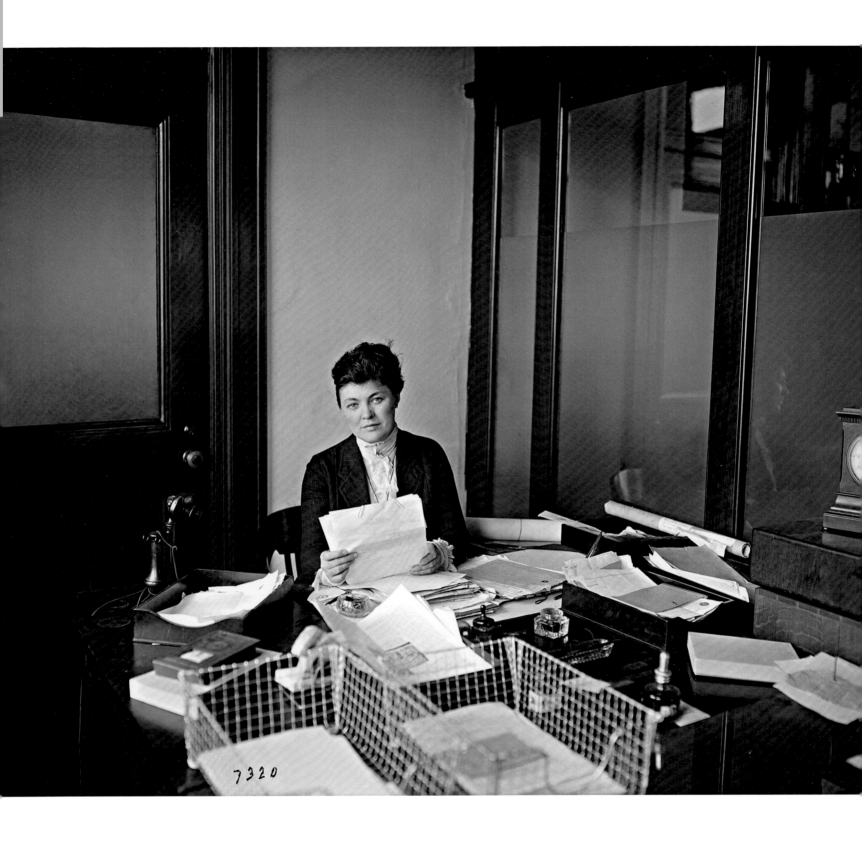

7320

Photo at main office, heads of department,
Department of Bridges, July 20, 1922

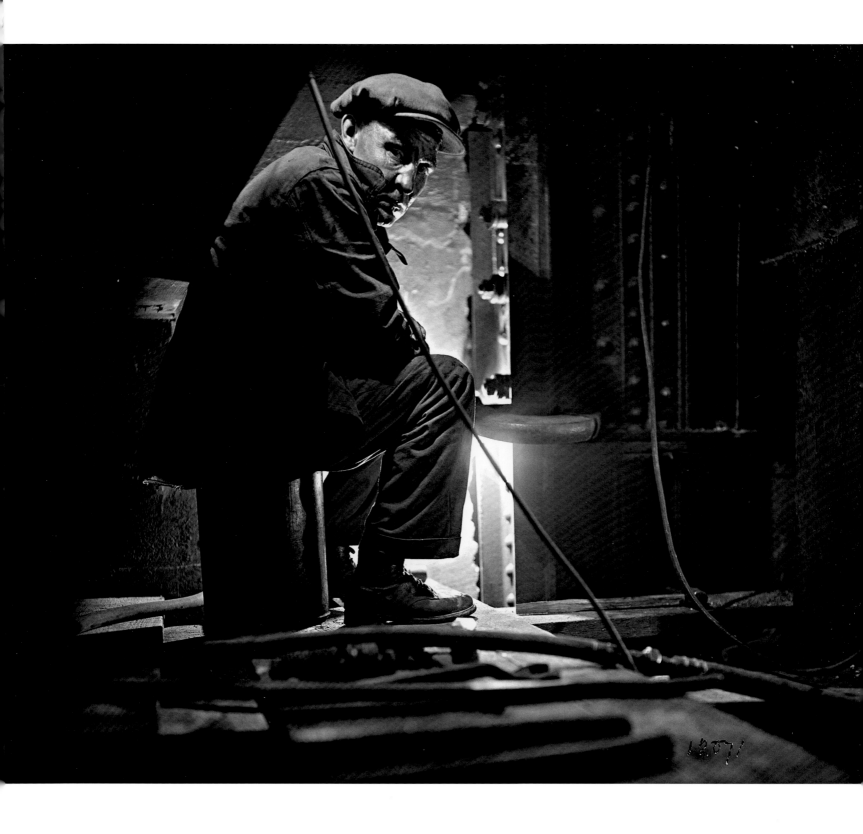

Brooklyn Bridge, new William Street subway
cut, November 19, 1928

NEW YORK CITY MUNICIPAL ARCHIVES

Founded in 1950, the Municipal Archives preserves and makes available the historical records of New York City municipal government. Dating from the early seventeenth century to the present, the Municipal Archives' holdings total approximately two hundred thousand cubic feet. Accessioned from more than one hundred city agencies, the collections comprise office records, manuscripts, still and moving images, ledger volumes, vital records, maps, architectural renderings, and sound recordings. In 1977 the Municipal Archives, the Municipal Reference and Research Center (now known as the City Hall Library), and the Municipal Records Center were brought together to form the Department of Records and Information Services. In 1984 the Department of Records moved into the landmark Surrogate's Court Building at 31 Chambers Street, originally built as the Hall of Records.

Highlights from the Municipal Archives include the vital records, censuses, and city directories that are an essential resource for patrons conducting family history research, the largest and fastest growing hobby in America. Records pertaining to the administration of criminal justice, dating back to 1684, constitute the largest and most comprehensive collection of such material in the English-speaking world. There are more than two million photographic images in fifty collections, including pictures of every house and building in the city, from circa 1940 and circa 1983. Legislative branch records date back to the first Dutch colonial government in New Amsterdam. Robert Moses' papers document construction of the city's vast infrastructure during the twentieth century, and the records of mayoral administrations provide extensive information about every aspect of New York City, from 1849 to the present.

The Municipal Archives is committed to long-term preservation of the materials in its care. The Archives maintains a book and paper conservation laboratory that performs complex document treatments, a micrographics laboratory to reformat materials, and a photography unit that produces new prints, transparencies, negatives, and scans from vintage photographic materials for both in-house use and for patrons. The photography unit maintains a traditional black-and-white darkroom and a state-of-the-art digital studio.

For more information, call (212) NEW-YORK or, in New York City, dial 311. www.nyc.gov/records

Municipal Building, room 1800,
Activities Board, January 7, 1927

ACKNOWLEDGMENTS

We gratefully acknowledge the support of Department of Records Commissioner Brian G. Andersson, Deputy Commissioner Eileen M. Flannelly, Assistant Commissioner Kenneth R. Cobb, Municipal Archives Director Leonora Gidlund, and Senior Counsel Katherine Winningham, plus the technical help of Michael Tedesco. We are also indebted to Eugene de Salignac's granddaughter, the late Dolores Parham, and to his great-granddaughter, Michelle Preston, for their participation and assistance. We would also like to thank the staff at Aperture, especially Ellen Harris for her enthusiasm, Lesley Martin for her long-standing support of this project, Nancy Grubb for her hard work and editorial vision, and Matthew Pimm and Sarah Henry for their commitment to production quality. Thanks also go to Miko McGinty and Rita Jules for their handsome book design.